The Architecture Exchange Workshop Series

2

The Architecture Exchange Workshop Series

Imagining Architecture Beyond the End Times

2

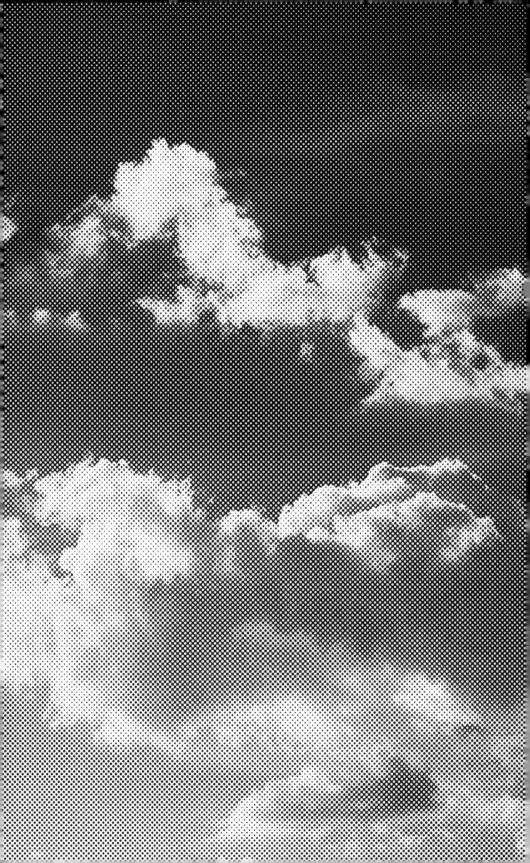

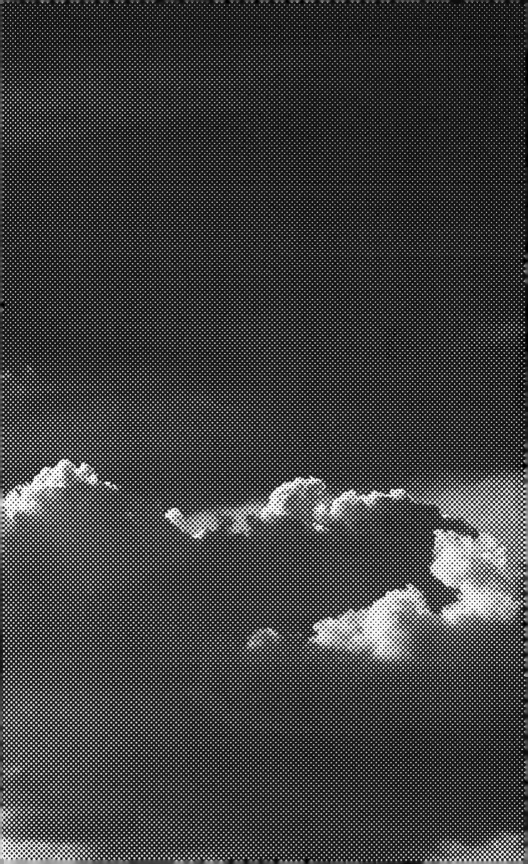

DEDICATION
TO

Jess & Maya

'Going beyond the end times, therefore, requires unmasking it as an ideology and showing how the current condition is neither new nor natural but contingent, related to multiple historical factors that can be fought and changed.'

The Opportunity of the End Times
Alessandro Toti, 1

SKETCHING
COVERING
INSULATING
CLEANING
DECORATING
FURNISHING
PROGRAMMING
LANDSCAPING

So Through a World of Piety We Make Our Way
Jaffer Kolb, 15

'Just as Cézanne paid tribute to painting as a practice whose progress was to be verified against painting's own tradition, so architecture, Rossi insists, is an autonomous practice with logics and procedures of its own.'

Things Made Whole
Cristobal Amunátegui, 25

'With Rowe, we can rebuke Tafuri's stoicism, challenge Koolhaas' cynical capitulation to the mechanism of alienation, and see architectural form as a tool for structuring the Žižekian "encounter of the two," and maintaining a permanent spatial corrollary of the Badiouian Event.'

Hope *through* Design
Joseph Bedford, 47

'The open project is a kind of triangulation between a series of instincts, intuitions, and hunches. It is motivated by the local granularity of each single project; the particular concerns, questions, associations, agendas, and theses developed for each context.'

The Open Project
Ryan Neiheiser & Xristina Argyros, 65

* * * * * *
 * * * * *
* * * * * *

Body Politic
Bryony Roberts, 83

'*Making Architecture* from Architecture is a pursuit with the aim of grasping the width and depth of architecture. If architecture is a way that we organize the world around us, then *Making Architecture from Architecture* is about evaluating what exists and rearranging that material towards architectural purposes.'

10 Steps for Making Architecture from Architecture
Andrew Kovacs, 95

'The underlying premise of the present book is a simple one: the global capitalist system is approaching an apocalyptic zero-point. Its "four riders of the apocalypse" are comprised by the ecological crisis, the consequences of the biogenetic revolution, imbalances within the system itself (problems with intellectual property; forthcoming struggles over raw materials, food and water), and the explosive growth of social divisions and exclusions.'

Slavoj Žižek
Living In The End Times

Introduction

At the beginning of the last century, western society was racked with a sense of crisis yet still confident about the possibility of social and political as much as material progress; slavery had been abolished and women had achieved suffrage, cities had been electrified, cars and jets had collapsed space and time, and telephones connected the globe. By contrast, at the beginning of this century, despite seemingly exponential material progress, western society is socially and politically paralyzed in a state of anxious malaise. When one hears the term "millennial" describing those born at the beginning of this century, one does not imagine prospectors at the frontier of new lands but lonely polar bears on an island of ice in a rising sea whose waters are filled with a mixture of ecological collapse, biogenetic chaos, global food wars, populist demagogues, post-truth politics, and the permanent militarization of civil society.

Several destructive fantasies have been driving global civilisation to its apparent precipice: the fantasy that a market society is a free society; that difficult political negotiations can be replaced with administration and diffused by economic growth; that growth is unlimited; and that change is impossible because human nature is ultimately violent and cannot be surmounted by culture, society and politics. Towards the end of the last century, these fantasies became ideological forces as hard as stone. Slavoj Žižek has summed up the sense of our lives as being increasingly lived within the "end times" by Hollywood's repetitive compulsion to imagine the end of the world through ecological collapse, asteroid impacts, and alien invasions, while nobody can imagine what a modest change to the current socio-economic system might look like. It is as if the entire western psyche has become hooked on shots of ever more catastrophic self-destruction in the hope that the sense of shock itself will be sufficient to catalyse change.

Imagining Architecture Beyond the End Times captures the reflections of a generation caught between the failures of utopian thought and cynical reason. The book seeks to re-tool old means in search of new ends; seeking new stars by which to navigate in an age of dis-aster, literally, an age without stars. The seven essays presented here are the result of a closely shared conversation. They are the labor of a week of collective living together, discussing the grain of our times and the task of future architectural theory and practice, and of the ongoing circulation and mutual editing of texts. While they represent small beginnings, the Architecture Exchange Workshop series contends that such small pockets of individuals, when working closely and intensely in conversation can produce significant contributions. While such small groups are only ever fragments, the fragment by definition contains the idea of the whole.

These seven gathered texts present differing reactions to the state of the present and to the conception of time and history as determinants of architectural imagination. They variously pose critique, provocation, aphorism and manifesto, with sentiments of confidence, anger, retrenchment, modesty, irony and hope. They are imaginative gestures aimed at kick-starting the faltering motor of history, in a world that appears too frequently, as the saying goes, to be blown backwards into the future. Yet despite their divergent sensibilities and strategies, they are stamped with the common threads of dialogue and conversation out of which they were formed.

Joseph Bedford,
Yorkshire, 11 November, 2016.

Photos of the

Workshop

The Opportunity of the End Times

Alessandro Toti [1]

While there are many diverse rubrics under which the condition of the "end times" might be understood, "post-modernism," "post-fordism," "neo-liberalism", or "late-capitalism," they all share a common paradox: that the new is presented as something natural rather than the result of historical circumstance. The end times are presented as the end of history, the end of ideology, while it is itself historical and ideological. As a consequence of the conception of time as at an end, the current state of politics and economics is treated as if it were beyond history, in a state of nature. Such an erasure of the historicality of the present dispels our anxiety about it, while preserving its most reactionary and conservative forms.

Going beyond the end times, therefore, requires unmasking it as an ideology and showing how the current condition is neither new nor natural but contingent, related to multiple historical factors that can be fought and changed.

HEGEL'S

Hegel's conception of the culmination of history, when the struggle between subject and object will come to an end, has often been thought of as the first definition of the end times, if by end one understands the best possible state in which human beings, finally became self-aware and free. Yet in the 1930s, the French-Russian communist philosopher, Alexander Kojève, overturned this approach, highlighting how Hegel's conception of history was not linear but circular.[1] According to Kojève's interpretation, the end times are not an eternally stable final state beyond the conflicts of history. Rather, what is perceived as the end times is no more than the turning point of a historical period. Kojève's view suggests that the end times must shed its tragic role as the final setting sun of the arc of historical time, and become a simultaneous sunrise. It is no surprise, then, that different end times have been declared many times in history. Hegel himself saw it in Napoleon and then in the Prussian State;[2] Kojève, in the opposition between the US and the USSR;[3] and Francis Fukuyama, in western liberal democracy.[4]

Living at the end times is, therefore, not an unusual condition, and even less a dramatic one. As Kojève explained, the end of history is not a catastrophe: "the natural World remains what it has been from all eternity. And [...] Man remains alive as an animal in *harmony* with Nature or given Being."[5] This harmony is not a liberating force, however, but a coercive and paralyzing one. It implies that the human species will be prohibited from making mistakes and producing disharmony as these are, by definition, against nature. "If Man becomes an animal again," Kojève writes, wars, revolutions and conflict might disappear, but so too "his arts, his loves, and his play must also become purely 'natural' again. Hence it would have to be admitted that after the end of History *men would construct their edifices and works of art as birds build their nest and spiders spin their webs*."[6]

Kojève's image of architecture at the end times being like the animal architecture of birds and spiders powerfully represents our current time,

1 Alexandre Kojève, *Introduction to the Reading of Hegel* (Ithaca and London: Cornell University Press, 1969), 88-99.
2 Ibid., 98.
3 Ibid., 159-162.
4 Francis Fukuyama, *The End of History and The Last Man* (New York: Free Press, 1992).
5 Kojève, op. cit., 158. See also Giorgio Agamben, *The Open: Man and Animal* (Stanford: Stanford University Press, 2003), 9-12, and Mario Tronti, *Dello spirito libero. Frammenti di vita e di pensiero* (Milan: il Saggiatore, 2015), 249-257.
6 Ibid., 159. (Emphasis Added)

in which architecture, like politics and economics, appears to be suspended in a state of unquestioned certainty, beyond history, as its best and final outcome. The rhetoric of architecture today reduces it to being a subset of nature, as the creation of shelter and comfort. Architecture, it is said, should be nothing if not "ecologically sustainable," "socially accessible," "economically profitable," etc. And as long as these new imperatives do not challenge the historical development of the underlying social and economic order, architecture can be free to be as decorative, playful, and innovative as it likes.

One of the results of this condition is professionalism. Rem Koolhaas said, for example, of his design for the Prada Foundation in Milan that "the philosophy at the heart of this Foundation is that there must be no more oppositions," that "differences [should] coexist in the most balanced way possible," and that the future is "in specificity, without excess."[7] What is most striking about Koolhaas' project is the fact that the majority of the media—in Italy at least—so unanimously praised it without asking themselves questions such as: why, in contemporary cities, are corporations the only actors able to provide public facilities?[8] What seems clear is that the architecture itself is not considered worthy of a political criticism. Media coverage focused only on the "perfect harmony articulated between past and present."[9] This celebration is a clear example of the ideology sustaining our present condition. Koolhaas' buildings might be clad in gold, but it is still no more than a bird's nest or a spider's web, securing shelter and comfort against the social and economic conflicts of history.

7 Rem Koolhaas, in Stefano Bucci, (*La periferia d'oro di Koolhaas, ecco la nuova Fondazione Prada,* www.corrieredellasera.it, 5 May 2015). Translation by the author.

8 See for example the review of the centrist newspapers *Il Corriere della Sera* (Stefano Bucci, *La periferia d'oro di Koolhaas,* www.corrieredellasera.it, 5 May 2015), which agree with the right-wing newspapers *Il Giornale* (Carlo Franza, *La Fondazione Prada a Milano, un regalo alla città diventata Capitale Europea. E con la mostra 'Serial Classic' lo storico Settis coniuga antico e contemporaneo,* www.ilgiornale.it, 5 May 2015) and the left-wing *Il Manifesto* (Teresa Macrì, *Un nuovo tempio dell'arte,* www.ilmanifesto.info, 16 May 2015) about the merits of the Prada Foundation. The international press such as *The Guardian* (Oliver Wainwright, *Rem Koolhaas crafts a spectacular 'city of art' for Prada in Milan,* www.theguardian.com, 6 May 2015), *The New York Times* (Carol Vogel, *The Prada Foundation's New Arts Complex in Milan,* www.nytimes.com, 22 April 2015), *Die Zeit* (Tobias Timm, *Glücksfall mit Blattgold,* www.zeit.de, 24 May 2015) and *The Architectural Review* (Tim Abrahams, *Fondazione Prada in Milan by OMA,* www.architectural-review.com, 21 September 2015) are little different.

9 Teresa Macrì, *Un nuovo tempio dell'arte.* Translation by the author.

While Koolhaas' approach remains dominant, a new sensibility towards a more 'political' architecture is, however, on the rise. Interest in 'political' architecture is, no doubt, driven, in part, by fashion. Yet, nevertheless, many architects are trying to engage with politics both in terms of direct engagements—against forces of gentrification, real-estate-speculation, gender normativity, the legacies of colonialism, etc.—and through the architectural discipline itself—designing architecture that provokes political interaction. Whether direct or disciplinary engagement, both approaches share the ambition to use architecture as a tool to shape a more just society.

The rise of this newly political focus is consistent with Kojève's model of circular history. After so many years of disengagement, it is understandable that the 'political' is gaining ground among architecture students, conveying a new optimism about the possibility of architecture as an instrument of political change. Yet this 'politicized' approach risks being transformed into yet another neo-avant-garde: however popular, it will be ineffective unless it can be aligned with real political change. And even if this new neo-avant-garde were to gain power and were able to act, one should return to Kojève's advice about the circularity of history. Because the history of architecture is full of attempts to establish order and regularity in the world to bring it closer to its end. All these attempts may be read as worldly transpositions of Augustine's *City of God*, the home of holiness and harmony that was dramatically opposed to the City of Man, source of sin and conflict.[10] As Jerusalem and Babylonia, they are two different places that human beings must choose between. Neither synthesis nor autonomy will ever be possible between the holiness of the first and the damnation of the second. All there will be is a ceaseless struggle. Le Corbusier's Plan Voisin is one of the clearest examples, the harmony of the modern city being contrasted with the flaws and conflicts of the historical city. Yet none of these efforts to establish the City of God on earth have ever been perfect and complete.

An alternative model to Augustine's *Civitas Dei* can be found in Ticonius's *De Domini corpore bipartito*.[11] Ticonius, a North African heretic theologian from 4th century B.C.E, devised a Church characterised by the compulsory coexistence of good and evil. Through an analysis of the Holy Scriptures, Ticonius highlighted how the body of God was not a

10 Augustine of Hippo, *City of God* (London: Penguin, 2003).
11 Giorgio Agamben, *Il mistero del male. Benedetto XVI e la fine dei tempi*, (Roma-Bari: Laterza, 2013).

single entity, but one composed of two different parts, each developing autonomously and inseparably. Though Ticonius was one of the main references for Augustine's *Civitas Dei,* it is easy to recognise the differences between them. Joseph Ratzinger once wrote that in Ticonius: "There is no apparent antithesis between Jerusalem and Babylon, that is so peculiar in Augustine. Jerusalem is at the same time Babylon. Both constitute one single city that has a 'left' and a 'right' body. Ticonius did not develop a theory of two cities as Augustine, but the idea of *one unique* city with two sides."[12]

The importance of Ticonius' thought could be summarized thus: it provides a model where, unlike the cynicism of Koolhaas and the utopianism of Le Corbusier, the political meaning of opposition is maintained. *De Domini corpore bipartito* offers a prompt to see dialectics as permanent—or as Giorgio Agamben writes, "immobile"[13]—with oppositions being continuously preserved from every 'original' and 'final' definition and conserved in the dual, enigmatic and ultimately ungraspable dimension of their signification. Ticonius's theology compliments Kojève's reading of Hegel. His conception of conflict without resolution further challenges the conception of the ideology of the end times as a final resolution of conflict. Thus paradoxically, Agamben's conception of the immobile, in his reading of Ticonius, preserves the conception of history, preventing it from collapsing into nature.

Living in the end times, deprived of significant political conflicts, one should not hope for a new saviour able to rescue society, or at least architecture. Instead, the end times provide the opportunity of understanding that every time is an end time, as no end has ever come and no end will ever come—the end indeed is always *about to come*. Just as humans need to establish themselves against nature, continuously striving for detachment, but without ever being able to leave nature behind, every architecture needs to think itself apart from nature, as an artificial and antagonistic entity that will never become completely autonomous.

Rather than promoting politics as a heroic neo-avant-garde, or as mere 'professionalism,' architecture should conceive of itself as a conflicted discipline whose oppositional character cannot be solved. Ignoring this dialectic only conceals reality and prevents change.

12 Ibid., 10. Translation by the author.
13 Giorgio Agamben, Stanzas: *Word and Phantasm in Western Culture* (Minneapolis: University of Minnesota Press, 1993), 152-158.

Conversely, accepting this torn condition means striving for a critical, operative representation of what exists while leaving a door open to what is to come.

There has been a strong aversion to the device of the wall in the past century, seeing it as guilty of preventing the harmonic or 'natural' use of the city and its spaces. The blind walls of the city in particular are viewed as anguishing urban wounds that urgently need to be stitched. So-called street art is one of the strongest medicines in blind wall therapy, covering them with references to ecology, culture and commerce. Financed by municipalities and corporations, street art is prescribed in order to dispel urban anxieties, producing 'unique' environments deprived of ambiguity and fracture.

On the contrary, the blind wall is a key element of the city because it represents the constitutive conflict between the finite and the infinite at stake in every relationship between architecture and the city. It sets limits to the space of individual harmony—the apartment—but at the same time admits the existence of its opposite—the unresolved and unresolvable dimension of the city. It is because it does not attempt an ultimate solution or compromise between either side, that the blind wall is one of the most concrete examples of what architecture always is: a discipline that, providing shelter and comfort, cannot *but* produce mistakes, conflict and history. •

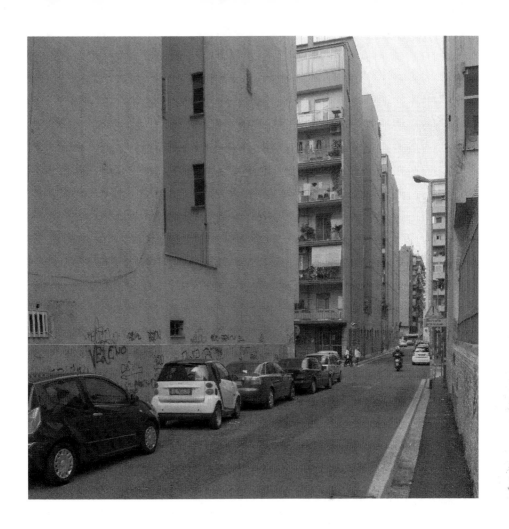

Blind Walls
Rome: Prenestino, Casilino and Appio Neighbourhoods. May 2015.
Photographs by Alessandro Toti.

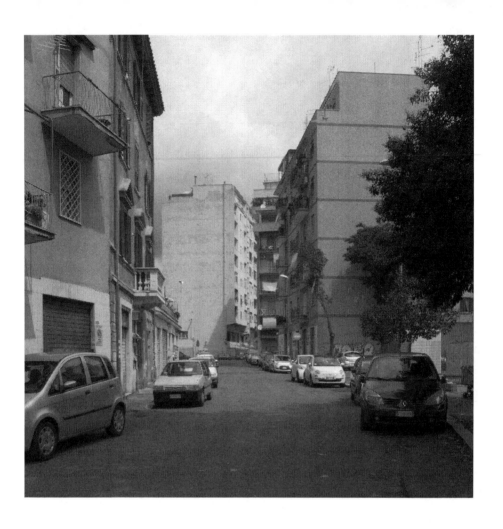

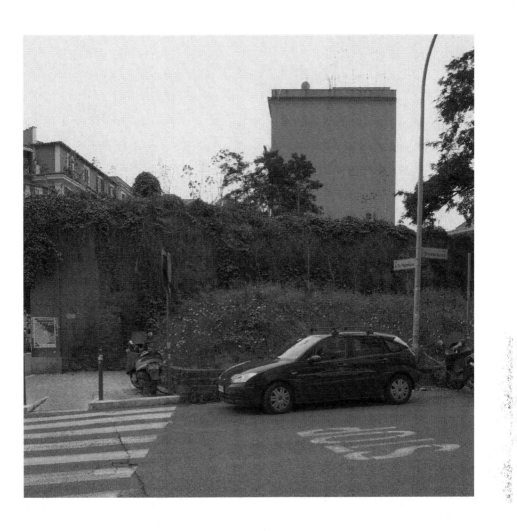

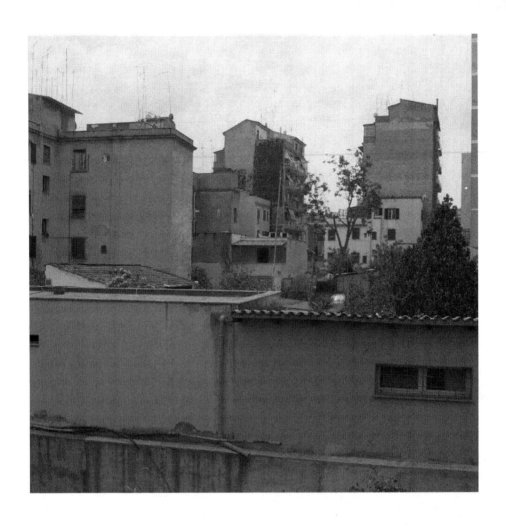

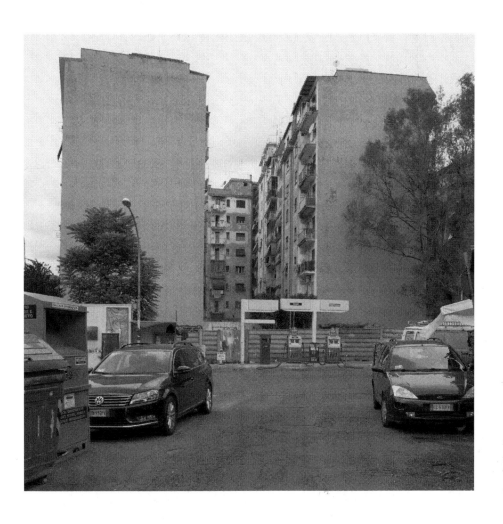

So Through a World of Piety We Make Our Way

Jaffer Kolb

We've probably all played the game where you repeat a word over and over until it loses meaning: when for a brief moment your head becomes overcast and everything slips out of order. Known as *semantic satiation,* hyperactivity causes a reactive inhibition that produces momentary incomprehension. In other words: physical mechanics and cognitive processing together produce nonsense. In this moment everything is full of potential.

Drag performance isn't about becoming feminine. It creates a third way that moves beyond traditional acculturation and into a world of sensorial references that are totally new while tied to things totally known. This neither denies nor respects what's there, but enters everything into a strange territory of floating forms—distilled but referential; familiar but purposefully ruined.

This is the basic script for what follows:

i. First formula: In some year, we learned something obvious and inherited, which seems weird and nostalgic and arcane when you think about it.
ii. Second formula: This boring thing is pretty remarkable. We might take it for granted.
iii. The tone should slide between catchy missives and a sense of gross longing.
iv. The approach should be parafictional—
history should be neither abused nor respected. Refer to everyone informally like you lunch with them.
v. Pink-wash whenever possible,
but never use the word queer.

Using the script, let's build a house. We'll begin with sketching, then covering (cladding), insulating (weatherproofing), cleaning (preparing), decorating (ornamenting), furnishing (inhabiting), programming (dividing) and finally landscaping. It might not look right, but we need to make a home somewhere.

SKETCHING

In 1956 we learned about the fabric of our fantasy. In their House of the Future, the Smithsons illustrated something that was hanging over all our heads, materializing a version of domesticity that lingered at an inevitable fringe. We thought we wanted seamlessness: the plastic monocoque a slick usher into an immaterial/material future where everything would be solid and nothing textured. Where house and furniture were combined into one, and where "machine" was a singular phenomenon—the house a machine for living, the age of *the* machine, and so on. We thought we wanted surfaces to replicate and multiply into a coherent, endlessly rotatable whole, where tactility and materiality flattened into smoothness and thickened into form.

In 1968 we learned, among other things, that architecture has its

own cycles of obsolescence. That it expires, both in use and in value, that it has a life-span like all objects. We learned this, curiously enough, from *Architectural and Engineering News*—curious only in that the proclamation was not one of speculative theorization or conceptual radicalism. Instead we learned this through a pragmatic call: an observation with a deliverable. Live quick, die young.

Industrialization asked that we consider architecture an object: replaceable, fallible, cheap and quick. The rapid replaced the enduring: from a uniform culture to one of perpetual outfit changes. Programmatic reassignment prefigured body transformation, typology itself constantly reinvented whether under the knife or through varied use.

With change comes re-tooling. Paul Rudolph reminded us that for centuries, the size of a brick was determined by what can fit comfortably in a man's hand so that building wouldn't exhaust him. Later, the man's hand was freed up (idly, perhaps), and it was the truck bed that dictated material dimensioning. Now it's a swipe and a pinch: a set of programmed digital gestures that bring back our hand: but now we only touch things that are smooth. Objects in Action, Kenneth Frampton calls them.

Digital gestures are pretty weird. There was a moment in linguistics when neologisms pertaining to the internet and digital culture had to be adopted globally and transliterated across alphabets. This accelerated an existing culture of language evolution to the point of absurdity, but was just the first glimpse of an even stranger emergent set of behaviors: digital gestures that paradoxically flatten culture in three dimensions. The world is famously full of unique cultural ways to flip someone off, but Cupertino has produced the gestural Esperanto.

COVERING

In 1956 we learned that seamlessness wasn't our fantasy. What we remember of the Smithsons wasn't the image of futurity but instead the realities of constructing images. The monocoque was wood-framed. The plastic was plaster. The surface hid nails. We fantasized about image first, its haptic banality second, and perhaps even third the role of the thickening of the wall: where a plastic future and the primal cave collided, leaving behind the pitched roof house as the useless in-between. It was both dumb and forward-looking; dismorphed, impossible, and highly achievable.

In 1861 we learned that architecture can be described by its microscopically thin surface. According to Semper, it is, in fact, reducible. Perhaps because horsehair and masonry were already

EVIDENT

evident, the poche ontologically coherent and not a Pandora's box, but reveling in architecture's apparent thinness gave it power: its monumental force produced through its smallest means. Its effects produced maximum returns on investment.

Masks are pretty scary. We can criticize the thinness of the mask as a cheap trick, or we can accept the depth with which the mask transforms. In the 1920s, the police would occasionally suspect that women in Northern Manhattan were men in drag, and tested out their suspicions by giving those bodies chase. Fast legs and the swell of the calf broke the mask as thin surface was revealed through heavy structure. Back in civilized society skirts fell low enough.

INSULATING

In 1995 we learned about dropped ceilings. Koolhaas explained that hackers climbed above ceiling tiles to explore the space in between floors: to map infrastructure. The site is visible and hidden from view. The tiles like little piezoelectric modules shifting and cracking. The ceilings have eyes. Vadding, it's called, basement nerds doing mission impossible: white crimes opening up new orifices in static objects. This act of invasion was welcome in the office, but never in the home. Domesticity at war started as a commentary of innovation through research, but became a holistic blanket covering all we thought we knew about our inner lives: our desire to build, to fortify, to occupy and to maintain. The stakes were pretty low individually, pretty high collectively.

Insulation is that it's both visual (the joy of discovering the pink panther insulation foam) and invisible. It has no material specificity, but absolute material performance. It's a drug: solipsistic and unreal, transforming and universal. It's a site of subversion: that lives in the walls, that might be a crumpled-up masterwork, that might kill you, that always protects you, that unambiguously creates the interior.

In 2002 we learned that we ran out of glue. This is the world according to Peter Eisenman, bemoaning our lack of instruments to reconstitute history. Eisenman was accusing Leon Krier of wanting to stick things back together—through pastiche, through assemblage, through collage, through reproduction. But he can't, because there is simply no more glue. But if glue is mimesis—maybe our parents won't know we broke the vase—what about tape? As a surface, tape masks. Underneath, tape transforms; the classic tuck-and-tape a perfect example. The deepest structural rift transformed through the most ephemeral means with a byproduct of gross friction: chafing and even blistering.

CLEANING

In 1916, we learned about hygiene. Irving Gill told us that he had been experimenting with the idea of producing a perfectly sanitary house. To do away with drudgery. Forty years later that would be through images of a technologically enabled housewife: Robocop without the gun, or the visor. Rosie from the Jetsons: modern womanness taken out of the purely feminine Jane and re-instantiated into a hybrid anthropomorphic non-human.

But for Gill there was no other body: it was the building itself. Everything was finished flush. Corners were rounded at the ground to prevent dust from accumulating and vermin from hiding. Like a photo backdrop the house was conceived through fillets and edgelessness, as though edges harbored disease. In his construct everything was in plain view. Shadows were impossible. Continuity reigned.

A vacuum activity is slightly pathetic. According to Konrad Lorenz, it occurs when an animal is removed from its instinctive habitat and put into an environment without the same stimuli. The animal preserves habitual actions: a dog will bury an invisible bone in invisble dirt; a cat will chase invisible rodents around in circles. It's phantom pain, but purely behavioral. Writing on the debate between Leon Krier and Peter Eisenman, Roger Kimball calls Eisenman's house designs and Krier's fantasy islands vacuum activities: designing without material, pushing against invisible barricades and guided by ghosts.

Realtors are pretty creepy. Welcome to your new home: if you follow along you'll find all the amenities you'd expect in the house. You can't bring furniture, but also there is none here. You should probably start practicing yoga at home. I once toured apartments in London with a realtor who could only describe a unit by its adjacent restaurants and stores; who once couldn't even find a flat he was trying to show me and insisted that we sit in a nearby park and eat kababs and later called me to ask if I was interested in taking it.

DECORATING

In 1966, we learned that LSD might help designers achieve previously impossible creative breakthroughs. You can take it in architecture. There is a good chance you'll encounter something you can describe as architecture after taking it. In 2011, we learned that in the 1950s scientists experimented with giving housewives LSD and then tracking their experiences. Laboratory, the home, and the body merged into a single unit and, for a brief moment, were as seamlessly rotatable as the Smithson's house. It was an aesthetic experience (the experiment itself,

THE

the trip, the setting) with no discernable aesthetic outcome.

In 1928, we learned from Hannes Meyer that all things in this world are the product of a formula: the multiplication of function by economics. This formula probably takes into account everything, but maybe not taste, which we were taught by Charles Moore, is errant nonsense in the design of a house. Instead, a house is actually another formula: the goods and trappings of your life added to your dreams equals a place that is uniquely your own.

The formulation of such knowable relationships is comforting the same way that it was maybe comforting to know that a nuclear family should have four children or sex biology works precisely one way and one way only. Not the other way. Throughout the twentieth century we learned that the rational cannot account for divergence. That it resists confusion; that it is mathematically logical.

When he first visited it, apparently Bob Stern had issue with Philip Johnson's Glass House in New Canaan: it wasn't frivolous enough. We might understand the comment as a double critique—that it was frivolous to begin with, but in the end it couldn't even pull that off.

Frivolity, architecturally speaking, might stand on the other side of hygienic seamlessness. That is, rounded corners and shadowless interiors that cannot be frivolous. Gill's interior breaks from the otherwise predictable dialectic between function and ornament, instead realizing efficiency as the escape from drudgery—clinical interior paradoxically figured as an expression of middle-class luxury. Ornament is frivolous, and it's also a dust trap. Glitter gets everywhere; stains are visible with a simple blacklight, no matter how hard you scrub.

In 1965 we learned that science could serve design beyond the creation of weaponry and outside of the machinations of the military-industrial complex. Buckminster Fuller taught us that we could use innovation and research to sponsor the design of livingry. If design was taken out of the hands of war, it was taken too from the rich. For some people, you wear leather boots to step on abject body parts to get aroused. Ricardo Bofill called for a Versailles for the People, where the elements of decorative, highly ornamental architecture were leveled and distributed as a kind of socialist economy of architectural things, as though pieces of a stage set were dismantled and handed out evenly.

When Irving Gill wrote on simple cube houses, he lauded their childlike frankness and chaste simplicity. Ornament is either exclusionary or perverted; for the rich or for the lustful. Childlike and chaste reserved for, curiously, the denuded and sanitized interior: that same space where you can hose off the walls; bleach the floor and

pretend none of it ever even happened. Ornament's equation with opulence, luxury, and the feminized space of the interior and the court just one version of an untoward subversion. Gill's puritanical drive itself a mask for something that, in the shadowless light, can be that much more degraded.

Charles Moore allows you to decorate; when the intellectual work of designing a house isn't enough; when relationships between spaces, connections between programs, and volumetric organizations have been established. Then, in his formulation, we can gild lilies.

LEDs are pretty shocking. The cliché that they haven't yet been able to produce warm color temperatures shouldn't be taken for granted. New apartments are increasingly clinical, and domestic activities are cast in strange new lights. At a recent dinner the golden skin of a roast chicken took on an ugly, green-purple hue—a toxic shroud covering a pale-pink interior that reminded us why gilding is equated with luxury and bluing with working class labor.

FURNISHING

In 1973, we learned that a home is the host of many competing, simultaneous, and significant ergonomics. Etienne Grandjean went through the task of assigning values, relationships, and ideal proportions to all of these sites. The house was thus transformed into a single piece of dispersed, multiscalar furniture all serving many needs: but those determined to be effective to particular ends. Health, of course, would be a driving factor, but so too would certain postures that might contribute to a system of body-languages fit for normal society— rendering the man more rigid and upright, the woman more graceful and docile; back arched and chest out.

Bob Venturi used to cite Trystan Edwards to talk about inflection: a theory of gestalt that mines the ontology of individual parts over their arrangement. A house is a network of inflected gestures; an architectural orchestra of domestic movements coupled with disciplinary elements. The door, the floor, the window together comprising a spatial system.

We have been told many times that the house is a laboratory—a persistent theme in our recent history. We have been left with strange artifacts from this imaginary discourse: houses that act as manifestos for their authors; houses that perform in strange ways and that come out of radically different schools of style. But until we see evidence of Frankenstein children and other disturbing anomalies, it seems clear that all we are succeeding in doing is redesigning the containers around

WHICH

which the experiments take place. Our typical variables—materials, construction techniques, and aesthetics, in the words of Elizabeth Smith in her introduction to the Case Study House book—demonstrate mostly how little we are able to accomplish in our method of scientific inquiry. If the house is a lab, we have proven that many versions of intermixing still produce sameness.

PROGRAMMING

In 1966, we learned that the double-functioning element is both complex and contradictory. According to Venturi, it stretches between use and structure; it is both complex and conflicted, performative and passive. It might be used just as it might enact, a chameleon who exhibits similar characteristics to Koolhaas's kipple. Kipple, useless objects that multiply when no one is around to witness them, are the most dangerous kind of species: autoreproductive organisms that need stimulation to be aroused; no partner to share genetic material. The double-functioning element is bi-sexual and autonomous. It functions in multiple where kipple has no function, and yet together the two types describe a vast network of objects and architectures.

Between them we begin to address specific behaviors of the generic: that is, things exist in order to reproduce and also to trick. Giorgio Grassi warned us to be wary of wonder: to resist looking at exemplars among strange objects. Meanwhile Paul Rudolph pushed for a varied "appropriateness" of things. Theoretically the two would seem in counterposition, until you consider that difference is always mediated. A departure can be at the level of the detail—discomfort comes when the distance between the index and the subject grows too wide.

Foam mattresses are pretty weird. One time I had a memory foam mattress and the space to my left took on a slightly indented, curiously blobby form. Eventually, I realized that it was a kind of map of averages of everyone I had slept with over the course of a year and a half. By the end of it I think I started to get a sense of my type. But then the Heisenberg effect started to kick in and I would specifically choose people based on how they might inflect the imprint. Maybe sometimes I wanted a little more mass around the middle; a few added inches to the legs; something just a little meatier or with wider shoulders.

LANDSCAPING

In 1750, we learned indirectly that there are two causes of beauty: natural and customary. One is instinctual, the other learned. Charles Moore would later reframe Christopher Wren, indirectly, by outlining the

design of a house as a kind of choose-your-own adventure—a description of clients that tracks their movements through a house, surrounded by objects, and behaviorally conditioned by their particular desires. One person wants to gingerly step into a bath; the other sweep in; one to hear his neighbor's smallest breath, the other to be swaddled out of any sensory exchange.

In 1545, we learned of a Satyric Scene, the setting for a landscape or Satyric play, decorated with rustic objects arranged into a natural tableau. Aaron Betsky would later describe this as the queerest scene: of myth and where the everyday and the miraculous mix; where the man-made intersects with the natural, the real and the imagined—and use it to propose a counterarchitecture that would re-order everyday life. It's the space of Reyner Banham's Freeway: the movement between significant architectural and urbanistic spaces that are significant in equal parts with regard to space and program; public and private.

Follies are pretty gay: experimental, open, meaningless, programless, enabling, public, shameless. They stand as a part of another kind of sequencing, a picturesque organization of which they serve as a flamboyant maître-d'. Right this way, with a grin and chuckle. They host plays; they host weddings. They host elaborate fictions and contracts. You look through them, but then sometimes you're in them and you look at the ground. Sometimes you're walking up their stairs and you're looking at their rafters. Sometimes you try and build one but then you don't plan it properly and it lays on the ground, face-down, eventually buried under snow. ●

Things Made Whole

Cristobal Amunátegui

ONE

In the 1968 essay volume *Teorie della progettazione architettonica* appeared a piece written by Aldo Rossi entitled "Architettura per i musei" (Architecture for the Museums). The volume gathered transcripts of the lectures given in 1966 as part of Giuseppe Samonà's course at the IUAV, which included speakers Guido Canella, Manfredo Tafuri and Vittorio Gregotti, among others. The essay title – a reference to Cézanne's famous statement, "I paint only for museums" – already lays the ground for Rossi's argument. Just as Cézanne paid tribute to painting as a practice whose progress was to be verified against painting's own tradition, so architecture, Rossi insists, is an autonomous practice with logics and procedures of its own. These were not easy times for anyone to make a historical claim such as this. It was a period of intense student radicalisation, and of continuous self-doubt as to the function, attributions, and boundaries of architecture. Indeed, the essay reflects Rossi's unease with the increasing reliance on technocracy, and rejects the departmentalisation of architectural education into specialisms largely shaped by the scientism of the period. Rossi's claim, then, is that there is enough historical evidence for everyone to see that architecture

- is a body of knowledge all its own, a "real argument"[1] in the world,
- which needs not explain itself "on borrowed knowledge external to it."[2] The words he uses are unambiguous: "if one had to write truthfully about the history of today's architecture ... one could write about the *misery of architecture.*" The compulsion for constant reinvention, the perpetual search for stimuli and legitimation in disciplines outside architecture, were for him "a sign of weakness and extreme cultural
- fragility."[3]

"Architettura per i musei" is a self-assured piece of writing, and an important one in Rossi's early body of work. The essay is urgent, yet devoid of the decade's strands of formulaic radicalism. Paired with other articles in the volume, it offers enough perspective to bring some air into the period's battle cries against anything vaguely resembling buildings. Even for those engaged with architectural ideas in 1966 there might be something unusual in a text bringing together figures as diverse as Raymond Roussel, Adolf Loos, Seneca, Borromini and Mies van der Rohe. Rossi also quickly moves on to establish his own constellation of influences. He celebrates Francesco Milizia's enlightenment approach to architecture which insists on its dependence on man's intellect, rather than on the imitation of nature, thus posing architecture as a deeply historical practice. He builds likewise on Viollet-le-Duc's rationalism, which conceives of architecture as a *creation humaine,* as well as on Le Corbusier's ability to formulate "clear problems" of architecture. But above all, he follows in the footsteps of Loos' famous dictum – that architecture can only be described – and those of Roussel, whose book *Comment j'ai ecrit certain de mes livres* (*How Have I Written Certain of my Books*) moves him to urge that "all those who imbed themselves seriously in architecture" must tell "how they have created
- certain pieces of their architecture."[4] Enlightenment rationalism and modern subjectivity, in short, are the two elements Rossi attempts to reconcile in moving towards a theory of architecture.

Yet even if Rossi's interest is to argue for the need for a cohesive theory in light of an architectural culture that appeared increasingly fragmented, his essay does not waste too many words unravelling the wider historical circumstances that led to the state of affairs he found

1 Aldo Rossi, "Architettura per i musei/Architecture for Museums," *Teorie della progettazione architettonica,* ed. Chiara Occhipinti, (Milan: Politecnico di Milano, 2013), 25.
2 Ibid., 30.
3 Ibid., 26.
4 Ibid., 27.

himself contesting. Needless to say, Rossi did not write in the voice of the historian, and although he mentions the excessive rhetoric of function and method incubated already in certain modernists like Gropius as cause of the current "misery," he is not willing to pause there for too long. Implicitly present in the essay, however, is the Rossi reader of Marx and the student of Tafuri, someone who knows full well the effects of the crisis of bourgeois culture and of the consolidation of the market economy in the domain of aesthetic production. This is a Rossi for whom the disarticulation of architectural practice and theory in favour of quantitative planning, say, or anti-institutional radicalism, is not only a consequence of modernism's "naïve functionalism," but more broadly of the naturalization of architecture as a mere code in a wider dogmatic script. In what follows I will try to build on what seems to be the main challenge posed by Rossi's essay – the ambition of producing an architectural theory in a period when society seems unable to keep a stable relationship between its ideologies and its forms. After all, what theory could ever bring cohesion to a state of affairs whose very engine, the market economy, thrives on the relentless fragmentation and circulation of its parts?

TWO

One could say that any effort to formulate an architectural theory is always already an attempt to organize the world. Through their writings and buildings, both ancients and moderns strove to weave together nature and culture, sensation and phenomena, technology and artifice, so as to build integrated 'cosmologies' that could link the spheres of life. In order to do so, they welcomed the facts of reality to produce architecture's own tools and procedures. Vitruvian theory, to begin somewhere, built on the Greek tradition to extract its mimetic themes from nature. Vitruvius reflected on the city and provided guidance as to how to organize human activities according to plans. He named architectural elements, and even taught how to build the machines necessary for the construction of buildings and other architectural artefacts. In short, he created a concrete system of knowledge, uniquely architectural, although organized around the facts, beliefs and values peculiar to late classical culture. The ten books that it took for Vitruvius to complete his task were proof of the intellectual labour involved.

Where Vitruvius' *De Architectura* produced a body of knowledge through texts and drawings, the Roman Pantheon built it, becoming the enactment of an as yet unformulated idea, the result of precedent and practice. Rossi took it as an exemplary monument, the model of a

BUILDING

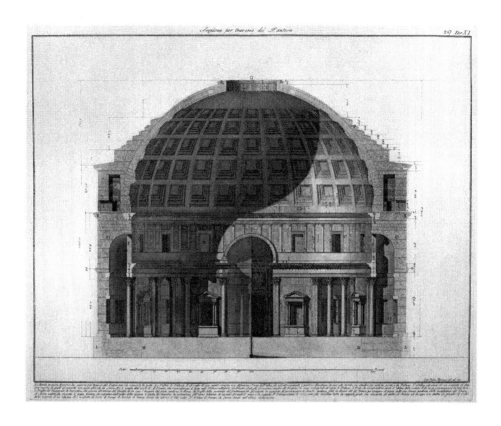

Fig 1: Giovanni Battista Piranesi,
Transversal Section of the Pantheon.

building whose logics, and therefore whose argument, could be described plainly – "the Pantheon can be described, the buildings of the Secession cannot."[5] Yet to Rossi's reading we could add that of Alois Riegl's, who used the Pantheon as an instance of an architectural *Kunstwollen*, to the extent that it acknowledged the changes in subjectivity of late Roman antiquity, it also offered the Romans a hitherto unknown field of perceptual experience. For the Pantheon not only formalized the problem of the public interior, which had been absent in the Egyptian pyramid or the Greek temple. It did so by carving the interior surface through myriad degrees of depth. The Pantheon presented a complex set of spatial, material, and historical relationships that ultimately tied together nature, myth, technique and sociality.[6]

Take as another example of an 'architectural cosmology' a completely different programme, like that of Durand's in 19th century France. Durand put aside problems of style to pose instead the pressing questions of function and organization in the *Précis des leçons d'architecture*, the catalogue of endless typological combinations that he produced and taught at the École polytechnique. The *Précis* was indebted to taxonomical methods advanced by the natural sciences, yet more importantly, it responded to the crucial encounter between the social needs of post-revolutionary France and the beginnings of industrialization, with an exhaustive manual that brought together problems of use, form, economy and pedagogy. As yet a further example, consider Loos in the context of turn-of-the-century Vienna. Inasmuch as he reformulated the domestic interior by presenting it as an enclosed system of unprecedentedly rich spatial possibilities, he was also responding to the growing gap opened by the modern city between the physical world and the world of perceptions. Showing remarkable persistency, architectural theory and practice continuously aimed at the creation of concrete artefacts where the realms of life could be integrated and made whole. This is likely what Rossi referred to when he spoke about the ability of architecture to formulate "real arguments" in the world. But surely there was more to these projects than the effort put forth by architects.

5 Ibid., 30.
6 If we agree with Giedion's proposition, the building was created for "great crowds of people," rather than "for an elite few." Sigfried Giedion, *Architecture and the Phenomena of Transition: The Three Space Conceptions in Architecture* (Cambridge: Harvard University Press, 1971), 146-148. See Alois Riegl, *Late Roman Art Industry*. Trans. Rolf Winkes (Rome: Giorgio Bretschneider Editore, 1985), ch. 1.

To repeat a well-known argument: the late-classical Rome of Hadrian, the fifteenth-century Italy of Alberti and Brunelleschi, the neoclassicism of Labrouste and Schinkel, Sullivan's late nineteenth-century Chicago, Loos' fin de siècle Vienna—these were all societies where capital, the sciences and the arts were in constant dialogue, mutually scrutinizing one another, revising their forms, keeping tensions and pressures alive between themselves and society. And by society I mean no more than a social basis that "holds in solution the contradictions between its classes,"[7] to use Clement Greenberg's formula. A society, the argument goes, where the communicating vessels are such between the various social strata that the art of the salon still has something to say to both, the lawyer and the clerk. In the nineteenth-century it was a strong bourgeois culture that served as the basis for aesthetic practices to organize their themes and revise their tools, once it became evident that the old absolutes of nature, authority and religion were no longer able to dictate their forms. One of their own, Balzac described his class as well as criticized it. Baudelaire dedicated his famous Salon of 1846 to remind the bourgeoisie of its duties – "you are the force . . . The government of the cities is in your hands."[8] In Vienna, Loos was both cause and effect of a similar amalgam, and for the same reason, his writings and buildings still meant something for a milieu wider than merely that of architects. This is the very fabric that begins to break in the later decades of the nineteenth century, and continues to dissolve into the following century, once the bourgeoisie withdraws to protect private interest in the face of growing class struggles.

THREE

What comes after the bourgeois withdrawal from the public arena is the inevitable rearticulation of aesthetic practice, the revision of the techniques and motifs that made aesthetic producers an active organ of society. If the renewed energy of the 1910s and '20s architectural avant-gardes was built on the remainders of bourgeois culture, then after World War I and up until the 1960s—years when the project of the welfare was still at stake—advanced practices within architecture attempted with varying degrees of success to side with the state in order to advance their programs. Indeed, the astonishingly rich production gathered under the umbrella of modernism proved that

7 Clement Greenberg, "Avant-Garde and Kitsch," *Partisan Review* 6 (Fall 1939), 44.
8 Charles Baudelaire, "To the Bourgeois," in *The Mirror of Art: Critical Studies by Charles Baudelaire* (New York: 1956), 38.

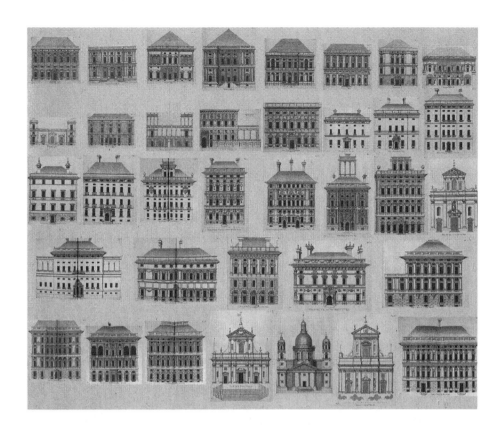

Fig 2: At the scale of the city, an example of an integrative architectural artefact is the phenomenal system of buildings known as the Palazzi dei Rolli, an effort carried out in the sixteenth and seventeenth centuries by the city of Genova in conjunction with the aristocracy of the time. Peter Paul Rubens made a complete survey of these buildings, which he published in a compendium entitled *Palazzi di Genova* (1622), from which this image was extracted. Inasmuch as the Palazzi were the houses of the nobility, they were meant to host visitors of high rank, yet their doors were open to anyone interested in viewing the art collections stuffed in the ground floors. In the process, the Rolli became one of the first modern instances of an "urban architecture," an architecture of the city conceived from the fragment in order to construct urban life. Organized in a sequence comprised of atrium, cortile, stairs, and garden, each building within the system explored variations on similar themes, offering a generous catalogue of typological possibilities. These were private buildings, of course, but they fulfilled a fundamentally public role.

buildings were still considered epistemological objects capable of internalizing the conflicts and excitements of the period. Buildings now strove to build concrete relations assembling the arts and industry, work, hygiene and recreation, the car and the pedestrian, man and the machine—to a degree they were still the embodiment of the nineteenth-century myth of humans as second creators.[9]

Alas, the number of propositions launched in these years proved inversely proportional to the place architects were to occupy in the public debate. In fact, even as they launched theories and designed buildings with incredible self-assurance, from the 1950s onwards there is something unavoidably salesmanesque about the figure of the architect, proof enough of their increasingly marginal place in the overall economy of power and knowledge. It is true that no period saw so many buildings built as did the period of post-war reconstruction, and it is doubtless right that some of these state-led ventures became the architectural laboratory of a generation (think of the INA Casa in Italy, to name but one). Yet it seems that no sooner did the project of the welfare state prove fragile in the light of an ascendant neoliberal ideology, than the status of architecture as an intellectual activity—a field able to capture the excitements and conflicts of the period and imbue them with form—began to decline.

A bureaucratized academia and the adoption of radicalism as convention—both the targets of Rossi's criticism in 1966—were two of the concrete consequences of this new state of affairs. A third path was the architectural variant of what Clement Greenberg called *kitsch*. Greenberg's words are familiar: kitsch is a culture born of the dissolution of the social basis that had previously constituted both the support and counterpart of advanced aesthetic practices. Kitsch, then, is a culture that uses "for raw material the debased and academicized simulacra of genuine culture, welcomes and cultivates this insensibility. It is the source of its profits."[10] More broadly, however, kitsch's conflict manifests in the "platitude that art becomes caviar for the general when the reality it imitates no longer corresponds even roughly to the reality recognized by the general."[11] Probably a good account of architectural

9 Michel Foucault referred to this in terms of the "great eschatological dream of the nineteenth century." the will to liberate man "from all the determinations from which he was not the master." Michel Foucault, "Foucault Responds to Sartre," in *Foucault Live,* trans. John Johnson (New York: Semiotexte, 1989), 36.
10 Greenberg, 40.
11 Ibid., 46.

kitsch is Hal Foster's concise description of the AT&T building in the pages of *AA Files*: "a global communications corporation wrapped in the nostalgic image of a national vernacular (the Chippendale motif) and placed in the anachronistic setting of the neo-classical public sphere (the façade and the atrium), when it is precisely such multinational telecommunications corporations as AT&T which have rendered obsolete such vernaculars, such public spaces."[12] One could argue that there was yet a fourth stream of the period, which was that forged by the peculiar neo-avant-guardism that flourished in the American East Coast. Reinterpreting the notion of autonomy explored by neo-avant-garde art practices—one that shifted towards conceptualism, as if reinstating the historical avant-gardes' claim that art must sever ties with bourgeois culture to protect itself from it—this current dismissed architecture's functional aspects and the conflicts of the city, to favor instead the production of a conceptual architecture in tune with philosophical and linguistic trends of the epoch. In the process, buildings were stripped of their political significance, loosing too their agency as artefacts able to integrate the natural, the technical and the social orders.

I am aware that there is a slightly formulaic tone in this narrative: in its excessive brevity it flattens events and ideas worthy of more generous treatment, and the linearity of the account makes it appear teleologically tragic. Needless to say, the late nineteenth-century crisis of bourgeois culture was not the only crisis of modernity. In the field of aesthetics, the encounter of a stagnant neo-classical academicism with the traumas and hopes unleashed by modernization remains as good a reason to explain the rise of the avant-gardes in the 1910s and '20s. Philip Johnson's AT&T building offers degrees of complexity and legibility far greater than more recent examples of kitsch, the veritable simulacra of the simulacra. On the other hand, one may still agree with Greenberg's core narrative of kitsch—that of the middle classes relinquishing serious art in favor of a mass entertainment industry devoid of social practice—although one suspects there must be more to the bonds established between architecture and spectacle than mere bourgeois conformism. And yet it seems clear from today's perspective that these four streams—technocracy, radicalism, the new values organizing mass culture and a neo-avant-guarde abandoning its political function—led to a period of systematic deculturization in architecture.

12 Hal Foster, "Neo-Futurism: Architecture and Technology," *AA Files* 14 (Spring 1987), 25.

By deculturization I mean the process that untied the very stuff from which architecture was produced, no matter whether in the late classical period or at the height of modernist vanguardism; a process by which the bonds between past and present, nature and technique, institutions and subjects were routinely unbounded. This might have been the price that many schools of architecture thought necessary to pay for the discipline's subsistence, particularly in the face of social discontent and increasingly rampant neoliberalism, but the toll was undoubtedly high. Schools brought the study of history almost to the brink of disappearance, and moved on to split into departments of social studies, urban planning, and technology and fabrication. To design buildings, to learn their histories and theories, became for the most part an anathema. This is how O. M. Ungers recalls his exit from TU Berlin in 1968, "Designing as a process was practically wiped out. One was not allowed to design because it was regarded as a bourgeois activity."[13] Rossi, we have seen, went even further in his essay of 1966, talking about "architectural misery." In this context, if the strain of radicalism took the path of participatory activism,[14] then kitsch popularised the understanding of history as a toolbox for endless form-making, turning architecture into a series of historicist exercises devoid of any connection with the city as a ground of conflict. To use Greenberg's words again, where "the avant-garde imitates the processes of art, kitsch . . . imitates its effects."[15]

FOUR

Rossi's impatience with what he called a state of "extreme cultural fragility," was also an impatience with the end of an order that was organized around the idea of aesthetic value; that is, around the notion that, even beyond subjective judgement, there was a history, and hence too a system of hierarchies, of qualities and missteps, successes and failures upon which art's forms of choice had to be built, and against which they had to be measured. For Rossi, cultural fragility meant the end of that order, organized as it was upon a social basis in need of

13 Oswald Mathias Ungers, "An Interview with O. M. Ungers," Rem Koolhaas & Hans Ulrich Obrist. *Log* 16 (Spring/Summer 2009), 32.
14 Save for exemplary instances like SAAL in Portugal—born of the 1974 revolution, a process where architects reinforced rather than relinquished architectural tools and procedures—participatory activism has remained a valuable social practice, perhaps, but rather insignificant in its effects, at least when compared with the best welfare state operations on the housing problem.
15 Greenberg, 44.

such forms, and its replacement with a regime of specialties, each struggling to establish dominance on each other. In 1966 Rossi was concerned with the formation of an orthodoxy of increasing technophilia that rejected architecture as a historical practice; an orthodoxy emerging in part as the result of a body of students routinely pressing for schools to reorient their function towards social issues. Rossi's problem, the difficulty he was trying to overcome in his essay and more broadly in his *L'Architettura della città* of the same year, was how to articulate a system of values for the production of architectural work, even in the absence of cultural cohesion.[16]

Not far from Rossi, O. M. Ungers' reconsideration of pre-scientific systems of thought was part of the same critique. Metaphors, analogies, signs, symbols, allegories; this is the stuff from where Ungers built his theory of the dialectical city, which uses the contradictory facts of reality as a set of tools or "vocabulary" for an integrated morphology of the city. "This approach is not meant to act as substitute for the qualitative sciences which break down forms, as we know them, into functions to make them controllable, but it is meant to counteract the increasing influence of those sciences that claim a monopoly of understanding."[17] Ungers wrote these words in his contribution to the catalogue for the exhibition MAN transFORMS, which celebrated the re-birth of the Cooper-Hewitt as the Smithsonian Institution's National Museum of Design in 1976. Conceived by Hans Hollein, the exhibition was perhaps among the last efforts coming from architecture to formulate a critique of technocratic society. In the introduction to the catalogue, the designer George Nelson held no punches in attacking a culture that in his view was "thoroughly conditioned to the belief that value can only be expressed in numbers, and that engineering know-how can solve all problems."[18]

Put in this way, there was more to the emergence of a generation of architects launching theories in the mid-sixties than a response to the eclectic pitfall in which most late modernist practices had fallen. More broadly, theirs was a critique of a subculture organized around quantitative values and specialization, a critique of an activism mistaking

16 A cultural cohesion, it might be worth insisting, which did not presuppose the dissolution of the category "class," but the collective administration of the conflicts germane to this category.
17 Oswald Mathias Ungers, "City Metaphors," In *Man TransForms: An International Exhibition on Aspects of Design.* Cooper-Hewitt Museum (New York: October 1976), 104.
18 George Nelson, Introduction, Ibid, 7.

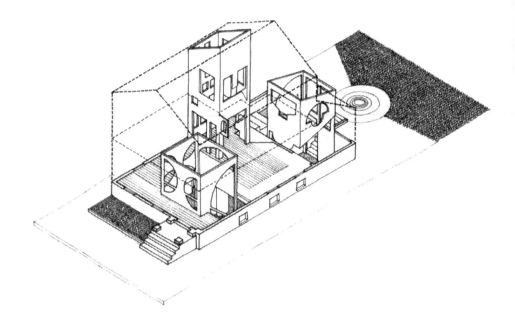

Fig 3.

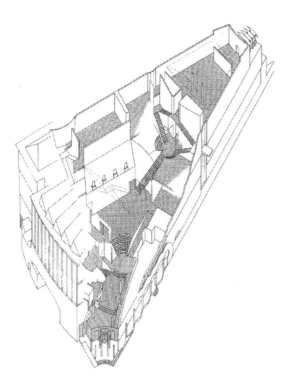

Fig 4.

Fig 3, 4: Adolf Loos' villas are an unavoidable precedent for the translations from city to building typical of several practices throughout the twentieth century. Charles Moore is a case in point, with the use of aediculae to introduce urban logics within the house. Another example is Hans Hollein's Museum for Modern Art in Frankfurt, where the building becomes the container of a series of spaces whose features are characteristically urban. The conflicts of metropolitan life are thus countered by the more integrated rearrangement of urban elements at the scale of the block and the building.

social problems for architectural problems, but also a response to the kind of ahistorical techno-euphoria that would rather see buildings drawn in cartoons than built as significant cultural artefacts in cities. In spite of their clear differences, the fact that Alison and Peter Smithson's theorization of the "as found," Rossi's "analogical city," Ungers' "dialectical city" or Robert Venturi's "difficult whole," relied on reality for their point of departure, can be taken as evidence that these practices were still committed to a project of integration, they still strove to weave together the spheres of life through architectural objects. Hence their focus on the rearrangement of fragments, to many degrees a romantic gesture, but also a move towards the reconceptualization of the city as a whole comprising contradictory phenomena. Rather than based on an ideal of cultural consensus, the value of these propositions is their acknowledgement of the impossibility of such agreement—the impossibility of "style" as a totalizing category—and their acceptance of the conflicts and facts of urban reality as the stock from which buildings and cities had to be fashioned. This is how Ungers summarized these views in 2004: "We live in a world that is built up out of historical form—I am not talking about the great history but about reality, about the small, banal history. If one fails to realize this and attempts to re-establish an ideal society . . . then it is condemned to fail from the start, because architecture isn't able to do that."[19]

FIVE

The theoretical claims made by Rossi, Ungers, et al. were prompted by a discipline evermore unsure of its age-old attributions and capabilities, from now on considered mere frivolities in the light of pressing social issues and the more "serious" concerns of the sciences. Not unlike in the sixties, today's hostility to architecture is manifested in an orthodoxy for which architecture is tolerable only when debated in terms of migration processes, climate change, media studies, communication networks or the flow of capital. Presented as a value, the "erasure of disciplinary boundaries" is possibly the most repeated litany of the past two decades, and judging from the work deployed in some of the most prominent schools in America and the UK, probably the most successful, too. What T. J. Clark recently said about contemporary artistic practice—that having blurred the boundaries between art, advertisement and entertainment, it now "glories in its

19 Ungers, 32.

nonexistence"[20]—one could apply to today's *engagé* practices in the field of architecture.

Lest they go unmentioned, let us take three events taking place in the past year to illustrate this. The PS1 pavilion in Queens in the summer of 2015 was awarded by the Museum of Modern Art in New York on the merits of an architecture that purified water: "[a] complex and advanced biochemical design, the stretched-out plastic mesh at the core of the construction will glow automatically whenever its water has been purified. In the stone courtyard of MoMA PS1, the party will literally light up every time the environment is protected,"[21] explained the Museum. To be sure, the pavilion's many architectural virtues could have been explained in less clichéd a way by a museum that once had the ambition of establishing itself as a producer of architectural discourse. Consider on the other hand the words of the 2016 Venice Biennale director, who announced in a newspaper article in late 2015 that he "will present numerous examples where organized communities and empowered citizens, sometimes without any formal design training, have been able to improve their own built environment."[22] The article was rather hyperbolically titled "It's Time to Rethink the Entire Role and Language of Architecture." The Tate in turn awarded the 2015 Turner Prize to a collective that offers "a ground-up approach to regeneration, city planning and development in opposition to corporate gentrification."[23]

But of course, very few would expect these groups to give serious responses to the global warming crisis. Nor do we believe they will make governments prevent the flows of oil or financial capital to keep turning our cities into fairgrounds for the multibillionaires. By the same token, one wonders, why an institution like the Venice Biennale should be charging "empowered citizens" with "no formal design training" to do what is in every sense the responsibility of trained professionals in conjunction with elected governments and parliaments. It seems almost too obvious to say that the best of the housing programs implemented

20 T. J. Clark, "Modernism, Postmodernism, and Steam," *October* 100 (Spring 2002), 161.
21 See http://momaps1.org/yap/view/19
22 Alejandro Aravena, "It's time to rethink the entire role and language of architecture," in *The Guardian* (20 November 2015). http://www.theguardian.com/cities/2015/nov/20/rethink-role-language-architecture-alejandro-aravena.
23 "Urban regenerators Assemble become first 'non-artists' to win Turner Prize," in *The Guardian* (7 December 2015). http://www.theguardian.com/artanddesign/2015/dec/07/urban-assemble-win-turner-prize-toxteth"

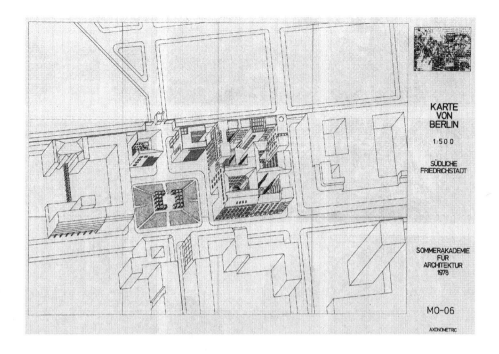

Fig 5: Similar themes are mobilized in some of Ungers's proposals, with a number of defamiliarized elements carefully reassembled in the urban block, which is thus articulated upon architectural fragments. These formulations constitute a thread that spans most of Ungers's academic work, but are perhaps most visible in the 1976-78 Summer Academy studios held in Berlin and New York—*The Urban Block*, *The Urban Villa*, and *The Urban Garden*—, where an array of operations including morphological combinations, typological transpositions, and the miniaturization of architectural elements was derived from, as well as re-confronted with, the found conditions of Berlin and New York. This image shows the work produced by Mathias Olbrisch in Checkpoint Charly. In *The Urban Garden: Student Projects for the Südliche Friedrichstadt Berlin*. Directed by O.M. Ungers, Hans F. Kollhoff & Arthur Ovaska. Summer Academy for Architecture, Berlin, 1978. Published by Studio Press for Architecture (L. Ungers, Köln, W. Germany, 1978).

in the last century have not been the result of political demagogy or anti-institutional tantrums, but the serious work of social democratic governments that were able to articulate political responsibility with professional architectural knowledge. If the mechanisms to force neoliberal states to take legal and economic measures in this direction are political, then of course, the kind of knowledge required for the production of urban-integrated housing projects is architectural.

Many may think it is not enough to simply work on the encounter between urban reality and the architectural tradition to sharpen the discipline's abilities in dealing with the pressures of contemporaneity. Rem Koolhaas' Venice Biennale of 2014 claimed that it is the industry of toilets, ceilings, floors, and facades that determines the aesthetic choices of today's architecture. He is doubtless right to say that portions of the world have been built this way for the past three decades, and they will continue to be so. Some parts of Milan may make us think we are in Jersey City in the same way Canary Wharf is no different from any financial district in the Emirates. Yet these are fragments whose mechanisms of persuasion no longer enjoy the health of decades past. They don't capture society's imagination in the way they used to, and it may be that the economy of images on which they profit is running out of steam. If there is any growing consensus, it is that the set of values built around the ideology behind these buildings will in no way deliver the promise of a socially integrated society.

If the last four decades have taught us anything, it is that architecture is a limited practice when it attempts to solve questions that are beyond its disciplinary reach. For the same reason, one would suspect that the criteria by which one could verify the success of architectural theory and practice is not so much whether these realms have beaten the housing deficit—would anyone blame doctors for the deficit of infrastructure or the lack of affordable healthcare plans?—but how architects have built these houses whenever they have been able to do so. Put differently, to discuss the INA Casa program in postwar Italy, the buildings that resulted from the SAAL process in Portugal or PREVI Lima in Peru as the result of the specific politics of each place and epoch is one thing. It is to talk about the conviction of certain public institutions, communities and individuals, and the consensus they achieved towards the construction of exemplary housing projects. To discuss the designs delivered by the architects behind these projects is another thing. It is to enter the realm of architecture, with its internal logics, and the capacity of these logics to transform the world. These might all be truisms, but they are important if we are to reinstate the

function of architecture in the general economy of knowledge, lest we keep entertaining the notion that the discipline will overturn neoliberal ideology, or its reverse, become a series of softwares and applications capable of bringing "intelligence" to cities. In 1966 Rossi urged architects to make explicit the architectural logics organizing their designs. The possibility of an architecture that engages with the world through "real arguments" is very much contained in this simple claim. ●

Hope THROUGH Design

Joseph Bedford

HOPES IN DESIGN?

In contrast to Manfredo Tafuri, who argued that: "there is *no hope* for architecture"[1] and no more: "'hopes' in design,"[2] I argue that hope in design is crucial precisely because the spatial form which is the very material of architectural design *is* the territory of social antagonisms, and that, as a result, architecture can engage with these social antagonisms *through* its design of spatial form.

1 Manfredo Tafuri, *The Sphere and The Labyrinth: Avant-Gardes and Architecture from Piranese to the 1970s* (Cambridge: MIT Press, 1987), 239.
2 Manfredo Tafuri, *Architecture and Utopia: Design and Capitalist Development* (Cambridge: The MIT Press, 1979), 182.

Tafuri, rather pessimistically considered architectural design to have become nothing more than a compensatory distraction from the reality of the economic and political antagonisms that structure daily life. He argued that design "masked,"[3] "dispelled" or "absorbed" true confrontation with those antagonisms. Following Slavoj Žižek, however, in turn following Jacques Lacan, we might describe Tafuri's view of design as one that sees it as nothing more than the "*objet petit a*," or object-cause of desire, of a collective fantasy by which antagonism is ideologically masked.

Yet as spatial form, architectural design is more than only imaginary. It is also real. Spatial form does create an image — and in this sense it does construct a fantasy — yet spatial form in architecture also structures social relations. As Robin Evans put it, plans "precondition the way people occupy space."[4] It is because the *objet petit a* of architecture is manifest *through* the same spatial form that belongs to the articulation of social relations that architectural design offers the means to critically engage with the antagonisms that are embedded within and through the history of architecture.

Tafuri once illustrated ideology in architecture using the example of the American metropolis. The "secondary elements"[5] of the city such as buildings receive all our attention, he wrote, "while the laws governing the whole are strictly upheld."[6] Ideology is at work in the city because architecture distracts us from seeing the workings of the city as a whole. Yet the ideology created by buildings would not be so powerful if it were merely a form of distraction. It is powerful because the object that attracts us promises to dispel the distance between the object and ourselves, that is, to lead us beyond the object itself to our contact with the real. As Žižek argues, ideology functions through fantasy. In fantasy "ideology takes its own failure into account in advance,"[7] the "very form of unfreedom is presented to you as a new form of freedom."[8] One is

3 See "Of the Gaze as *Objet Petit a*," in Jacques Lacan, *The Seminar of Jacques Lacan: The Four Fundamental Concepts of Psychoanalysis* (Book XI), trans Alan Sheridan (London: Norton, 1998), 67-123.
4 Robin Evans, "Figures, Doors and Passages," *Architectural Design* (April, 1978), 278.
5 Tafuri, Ibid, 13.
6 Manfredo Tafuri, "Towards a Critique of Architectural Ideology," in *Architectural Theory Since 1968*, ed. K. Michael Hays (Cambridge: MIT Press, 1998), 12-13.
7 Slavoj Žižek, *The sublime object of ideology* (Verso, 1989), 26.
8 Slavoj Žižek, Talk delivered at the IWM on May 5, 2015, accessed on November 25, 2015, <http://youtu.be/zvgl0Oy5wx8>, 36:29-38:40mins.

seduced by the object by the very promise of escape from it. Lacan famously illustrated this mechanism by describing the form of perspective paintings in which the vanishing point on the horizon is what subconsciously draws the viewer deeper into the seeming reality of the canvas precisely because it is the very point on the canvas, figuring the infinite distance away from the viewer, that embodies the promise of escape from the intervening illusion.[9]

In his own proto-Lacanian reading, Tafuri treated architecture as operating primarily on the plane of the imaginary, within this mechanism of fantasy. In order to break from Tafuri's pessimism, therefore, we must defend architectural design insofar as it also operates on the plane of reality, even we might say, of the Real, though of course this is to admit it is something with which we are in contact but about which we can never fully know. In articulating a less pessimistic stance we can also recover what Tafuri denounced with the distanciation of quotation marks, hope, and defend architecture as operating through what I will call, contra the mechanism of fantasy, a mechanism of hope. Where fantasy functions by absorbing the real within the imaginary, hope functions by maintaining a dialectical intersection between the real and the imaginary. In hope a distance is maintained between what is the case and what ought to be the case, and as such the real is confronted through a consciousness of this distance and yet a refusal to submit to it.

Fig 1
Mies van der Rohe, The Brick House, 1923. Image Courtesy of Artists Rights Society (ARS), New York and VG Bild-Kunst, Bonn.

Rather than being part of the mechanism to mask antagonism, hope *though* design, differently understood, is necessary for the mediation of antagonism. Architectural design only serves an ideological function

9 Lacan, *Four Fundamental Concepts*, 105-123.

when formulated as fantasy. When it is formulated as a dialectical relationship between the real and imaginary, architectural design serves to express hope and to reveal the contingency of reality by which reality's transformation can be catalyzed.

THE FANTASY OF FREE OPEN SPACE

Architecture can manifest its critique of ideology through the mechanism of hope, therefore, precisely *because* its core fantasy functions on the plane of the real as much as the plane of the imaginary. And this is so because architecture's principal *objet petit a* is its representation of *free open space*. There are many ways in which architecture can construct its fantasy of escape, yet space, as the dimension of architecture that inhabits the most structural level of territory and economics has been the principal way in which architectural fantasy has functioned for centuries.

The fantasy of free open space dates back at least to the ambitions of European territorial expansions that gave birth to the history of colonialism and, one could argue, to the spatial imaginary of modern architecture. Prior to the age of discovery, free open space was an unrealizable ideal for many Europeans.[10] But as European ships navigated the globe and settlers fled persecution to supposedly virgin continents, this previously unrealizable ideal became activated as a central symbol of freedom (or escape) at the heart of liberal capitalism. As Tafuri put it: "free-trade ethics met up with the pioneer myth."[11] The idea of free open space became the central vanishing point driving architecture's fantasy of escape, as much as that of liberal capitalism.

The long history of modern architecture can be understood in terms of the way it has represented the fantasy of free open space. It can be seen in various avant-garde gestures to open up architecture's enclosed spaces, and make the infinite horizon appear more immanent within the private interior. The history of the representation of free flowing space—from the picturesque garden and Gothic Revival, to the Wrightian and Miesian broken box and the De Stijl and Corbusian promise of the free plan—is a history of the fantasy of escape from the political contradictions and antagonisms that exist between the inside and the outside, the private and the public.

10 Open space was an unrealizable ideal for many urban settled civilizations, with the rare exceptions of moments of rapid conquest such as when Alexander the Great, spread rapidly Eastward through Persia, or the Arabs spread quickly through the middle-east, or when the Mongols moved freely from China to Germany.

11 Tafuri, "Towards a Critique," 13.

This fantasy of freedom began to shift away from its principal manifestation as a spatial fantasy in the postmodern backlash against modern architecture, yet it nonetheless continued in other terms through the structuralist and cybernetic imaginaries of mid-century vanguards like Peter Smithson, who among many others argued for an "*open aesthetic*" as the very "expression" of "liberation towards an *open society*."[12] This fantasy continues today, with all the ideological function that Tafuri spoke of, with the work of Rem Koolhaas, whose championing of "freedom" was perfectly aligned with the emergence of the neo-liberal logic of global economics after the fall of the Berlin Wall.

Fig 2
OMA, Welfare Palace Hotel 1976/77. Image Courtesy of OMA.

In the late 1970s, Koolhaas had already begun to recuperate the image of the American metropolis that Tafuri had once taken as an expression of ideology. Koolhaas made the very psychoanalytic description of ideology, which had once promised its unmasking, into a new vanishing point for imaginary capture. His new myth of Manhattan, for example, made metropolitan alienation into a source of erotic attraction, transforming it into an object of desire that architecture would now express. Where Tafuri's aim had been to demystify the mechanisms of ideology, therefore, Koolhaas' aim was to celebrate

12 Peter Smithson, in *Frontiers in Architecture CIAM '59 in Otterlo*, ed. Oscar Newman (London: Universe Books, 1961), 68. Smithson's words clarify the political subtext that has always attended the idea of openness in architectural design, in that his words implied the opposition between the openness of "Liberal Capitalism" in the West and the closed society of "Totalitarianism" in the Soviet East.

- them as the material of a new seductive fiction.[13]

Metropolitan alienation was to be accelerated through desire towards delirium, ending in the supposed freedom of the *Übermensch*. It was no longer a problem, in the way that Georg Simmel had considered it, but became a *promise*; that of an escape into a supposedly new realm of unparalleled creativity. The human species was to magically transcend the political realities of the city by absorbing the city within hedonistic practices performed within its architecture.

Fig 3
OMA, Welfare Palace Hotel 1976/77. Image Courtesy of OMA.

Koolhaas wrote of Manhattan, for example, that, "in such a 'system of solitudes,' each skyscraper becomes the lighthouse of an island that tries
- to lure the metropolitan public to the harbour of its interior."[14] Embracing the mechanism that Lacan knew too well, he wrote of one of his own projects, "the attraction of the multiple towers," "each with its own private yearnings—is made *more irresistible by the fact that it is unattainable* across
- the river. There is *no danger that their relationship can ever be consummated.*"[15] In

13 In 1975 Koolhaas argued that "communication with the public . . . can only be established with a literary effort to reform the seductiveness of architecture." Rem Koolhaas, speaking at the Conference "Practice, Theory and Politics in Architecture" on February 26th 1975, see Archive Tape, "10274 75 Roundtable 75" 38:35mins, Princeton University School of Architecture Archive.

14 Rem Koolhaas, "The City of the Captive Globe/1972," *Architectural Design 5* (1977), 331.

15 Rem Koolhaas, "Welfare Palace Hotel/1976-77," *Architectural Design 5* (1977), 344-345.

sum, alienation was to be transformed from a source of socio-political anxiety to a source of individual pleasure.

Koolhaas' formulation of desire, which he defined as "the immanent intimacy of the still separated,"[16] thus *absorbed* the very apparatus of ideology critique, and retooled its analysis of imaginary capture in order to extend the logic of imaginary capture. The sense of separation was to be accelerated such that the accompanying frustration would somehow enervate the drives and catalyze new collective relations based upon what we might call a kind of socio-political lust. Such a hedonistic conception of politics might be thought of as nothing other than post-politics, as hedonism and politics are mutually exclusive concepts.

Fig 4
Exodus, 1972.
Image Courtesy of OMA.

Koolhaas' embrace of heterosexual male pornography, in particular, can be taken as the principal sign of his overall strategy. Sexual references to masturbation littered his many texts, from "intellectual masturbation" to "speculative ejaculation,"[17] but pornographic images were the principal way in which his books were visually encoded with the celebration of imaginary capture.

Where the event of sexual encounter, as the transcendence of the

16 Rem Koolhaas, *Delirious New York: A Retroactive Manifesto for Manhattan* (New York: Monacelli, 1994), 243.
17 See for example, "The changes in this ideological skyline will be rapid and continuous, a rich spectacle of ethical joy, moral fever or *intellectual masturbation*. The collapse of one of these towers can mean two things: failure, giving up, or a visual Eureka, a *speculative ejaculation*." Rem Koolhaas, "The City of the Captive Globe," 331; And the "lone climaxes," "social intercourse," and "clitoral appendages," *Delirious New York: A Retroactive Manifesto for Manhattan* (New York: Monacelli, 1994), 41, 255.

self to the other, has been taken by many recent philosophers as an allegory for the event of political encounter, pornography, by contrast, in its mainstream heterosexual male version, represents the commercialization of the event as an imagined idea. In pornography, fantasy is not the self-owned fantasy of the individual but a socialized and normalized fantasy system produced by an extensive commerce of images. In addition to the problematic gendered power relations of the men and women involved in both the making and consumption of this kind of pornography, its problematic significance in Koolhaas' work lays in its function in recoding the mechanism of metropolitan alienation as positively desirable.

The sexual fantasies to be practiced in the cell blocks of Koolhaas' metropolitan architecture are presented as playing out the socialized form of desire represented in pornography. As Peter Sloterdijk has put it, however, analyzing the contemporary form of such metropolitan cell blocks, the desire to be practiced within them is the desire of the "also-wanting-to-experience-what-others-have-experienced."[18] Desire mediated in this way easily becomes "a form of consumer relations . . . practiced toward one's own sexual potential."[19] In the pornographic conception of desire, self and other in the sexual encounter are no longer positioned in a dialectical relationship with one another but are positioned at an absolute distance, afloat in a sea of images.

Yet sexual encounter must be understood as political: it is, as Žižek argues, "the encounter of the Two, which 'transubstantiates' the idiotic masturbatory enjoyment into an event proper."[20] For Žižek, the idea of sexual encounter as an encounter of the two takes on a political significance because it is an event in which the ideal encounters the real rather than mask it. Sexual encounter is the opposite of masturbatory enjoyment because one's imaginary is placed in a dialectical relationship with the real of the Other. In this sense hope, as we have discussed it, parallels Žižek's description of sexual encounter insofar as it too maintains a close proximity between the imaginary and the real, suggesting that hope has the quality of an event much as Žižek and his intellectual sparing partner, Alain Badiou discuss it, and that architecture can aspire to manifest a kind of permanently maintained event.

Koolhaas' work is the epitome of the mechanism of fantasy because it also further displaced its manifestation in spatial terms into the terms

18 Peter Sloterdijk, "Cell Block, Egospheres, Self-Container," *Log* 10 (Summer/Fall 2007), 105.
19 Ibid., 105.
20 Slavoj Žižek, *Violence* (London: Macmillan, 2008), 31.

of programmatic fictions. It distanced it one stage further from the very grounds of spatial form by which hope could be recoverd. Koolhaas' work has been the architectural corollary of pornography by which architecture has moved ever further away from the encounter with the city. And by coopting and inverting Tafuri's observations about the logic of metropolitan alienation and architecture's ideological function in distracting from the city, Koolhaas' work became the culmination of Tafuri's diagnosis of the failure of hopes in design. Despite all the claims that the turn to "program" and the rediscovery of "urbanism" within the building, Koolhaas' projects were only seductive images of such a turn, they absorbed the real into his B-movie screen play.

THE ENCOUNTER WITH THE REAL

Let us turn from Tafuri to Colin Rowe as an architectural theorist who maintained hope in design by maintaining the location of architecture and ideology on the level of spatial form. To introduce Rowe into our story we can imagine the scene of Rowe in 1972 in his study in Ithaca writing the text of *Collage City* in the evening, as Rem Koolhaas sat in the basement sketching up the diagrammatic form of his "City of the Captive Globe" with O.M. Ungers. We can picture Rowe turning on the television—assuming for a moment that he had one—to see the first broadcast image of the earth taken by Apollo 17 on December 7, 1972.

Fig E: The Blue Marble— Earth seen by Apollo 17 in 1972.

This image of our planet as a closed, finite whole, suspended in a void like a blue marble, can be taken as emblematic of a sea change which occurred at the end of the 1960s but which we are only still now coming to terms with. This image, punctured the long-standing fantasy of free open space and infinite growth that fueled the ideology of liberal capitalism for over three centuries. Carl Sagan famously remarked, on viewing our blue marble when only a pale blue dot seen from the edge of the solar system, that this image of the earth tells us once and for all about

THE

the finite limits of the earth, decisively dispelling the fantasy of escape and calling the species to recognise the necessity of political conflict within it:

> Our planet [Sagan wrote,] is a lonely speck in the great enveloping cosmic dark. In our obscurity, in all this vastness, there is no hint that help will come from elsewhere to save us from ourselves. . . . Like it or not, for the moment the Earth is where we make our stand.[21]

In our imagined scene, Rowe returned to his desk and penned the following challenge to the ideology of what he called the "open field," seeing its expression at work at the heart of architecture:

> In spite of the abstract universal goals demanded by theoretical liberalism, there still remains the problem of identity . . . The truly empirical order was never liberty, equality, fraternity; but the reverse: a question of the fraternal order, a grouping of the equal and like-minded, which, collectively, assumes the power to negotiate its freedoms[22] . . . Our history, [Rowe wrote] . . . *"is a history of the open field as an idea, the closed field as a fact."*[23]

Rowe argued his case for recognising the true closed spatial order of the earth on anthropological grounds, stating that political conflict was inherent to the human species and that it was better to confront this reality and deploy architectural space and form as a mediating device to negotiate it, than escape into the fantasy of the *open field*. Architecture's spatial form, in Rowe's hands, was more than simply a tool in a mechanism of fantasy; it was also a tool of hope in which the imaginary and the real were placed in an eventual relationship with one another.

As a composition of spatial form, architectural design could, on the one hand, articulate social fragments, negotiating their place within the city as a dialectical and historical topography; as he put it, a city based on "the conflict of contending powers, the almost fundamental conflict of interest sharply stipulated, the legitimate suspicion about others' interests, ... [and] a collision of points of view."[24] And crucially, it would

21 Carl Sagan, *Pale Blue Dot* (New York: Randon House, 1997), xv–xvi.
22 Colin Rowe and Fred Koetter, *Collage City* (The MIT Press, 1984), 116–117.
23 Ibid., 116–117.
24 Ibid., 106.

do so by articulating a distance between the imaginary and the real. Through representations that take up a relative distance from the city, architecture would struggle with the city and truly reciprocate it. As Rowe put it, "by supporting the utopian illusion of changelessness and finality" one "might even fuel a reality of change."[25] Architectural design would thus not simply operate by fantasy to mask reality: it would operate by hope to remain conscious of reality. It would establish a degree of estrangement from reality that recognizes its historical contingency and catalyzes its transformation.

Fig F: Inside Cover: Colin Rowe, Collage City (MIT: 1978).

In contrast to Tafuri, therefore, Rowe understood the potential of architectural form as a counter-force to ideology as much as its expression. His call for "survival *through design*" reads as a direct response to the pessimism by which Tafuri dashed all "hopes in design."

With Rowe, we can rebuke Tafuri's stoicism, challenge Koolhaas' cynical capitulation to the mechanism of alienation, and see architectural form as a tool for structuring the Žižekian "encounter of the two," and maintaining a permanent spatial corrollary of the Badiouian Event. Architecture structures true encounters through the articulation of territories and their boundary conditions that in turn structure identities and differences, the inside and the outside, the container and the contained, here and there, us and them. Architectural form remains a powerful tool in the critique of ideology precisely to the extent that it has been such a powerful vehicle of ideology's construction through the representation of space as "open". Architectural form challenges ideology in the way that it structures the struggle between "us and them" inherent to the form of the city, and mediates this struggle through a second axis, that of the struggle between is and ought. In this

25 Ibid., 149.

way hope *through* design is an engagement with real conditions. The real struggle of the city makes vital hope's reflection on what ought to be, and hope in turn becomes necessary in order to recognise real conditions as contingent facts open to change.

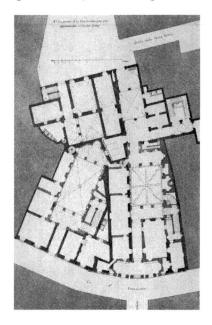

Fig G: Peruzzi's Palazzo Massimo Alle Colonne (1481 – 1536).

Rowe's own preferred architectural precedents were such buildings as the Palais Royale, the Hotel de Beauvais, the Palazzo Quirinale, the Palazzo Borghese and the Palazzo Massimo. He saw them as maintaining this double engagement between the *is* and the *ought*, negotiating the contradictions between inside and outside through the sculpting of thick masonry walls and articulated interior sequences formed of pure and compacted geometries. While the specific tools of poche, or agglutinated chains of rooms, deployed in these precedents might not be the tools architecture still uses today, they nonetheless remind us of the double engagement which architecture must perform in order to evade the captivating mechanism of fantasy at the heart of ideology.

The structuring of a relationship between the imaginary and the real, through architectural form might instead involve new relationships between the architect's imagination and the real conditions of the city. But by focusing on the potential of spatial form, and the logic of inside/outside around which real territorial and economic relations exist, and around which fantasies of escape are staged, architectural form, in other ways, can restructure this double engagement of hope *through* design. •

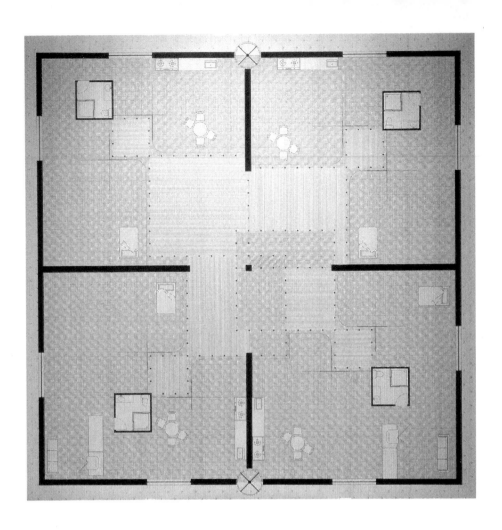

Joseph Bedford, *Four Square Quad House*, 2016

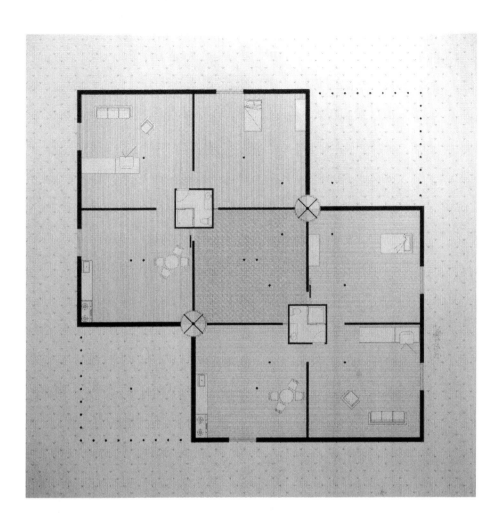

Joseph Bedford, *Nine Square Twin House*, 2016

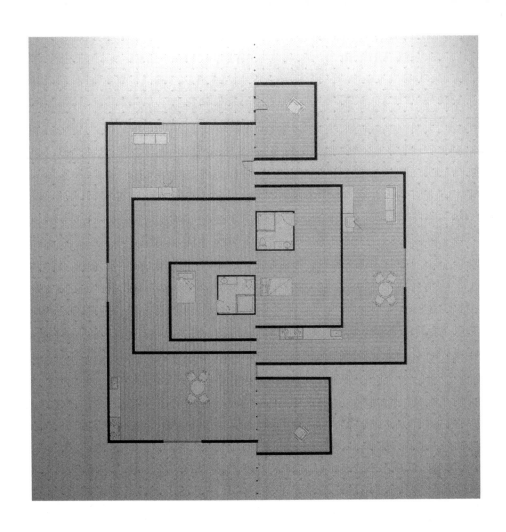

Joseph Bedford, *Linear Twin House*, 2016

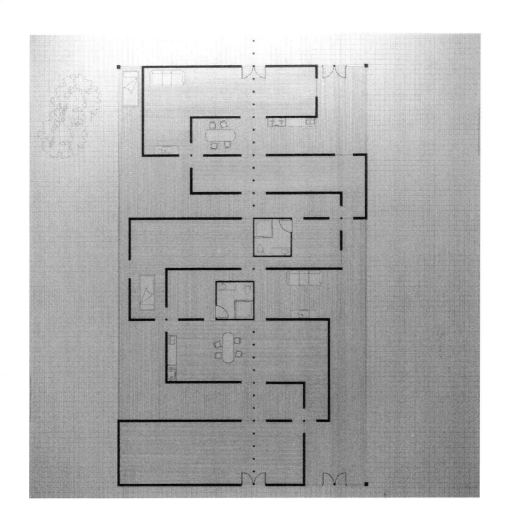

Joseph Bedford, *Sinusoidal Twin House*, 2016

The Open Project

Ryan Neiheiser & Xristina Argyros

Yes, our current world is getting more turbulent, complex, and crowded. And yes, architects are fading from relevance, struggling to remain socially and politically engaged; we are guilt-ridden, anxious, complacent, and confused.

The making of architecture is slow, and the discipline of architecture is mired in limiting, cumbersome, and tired professional bureaucracies. Architecture is having an increasingly difficult time keeping up with the conversation.

Within the discipline, we lazily rely on quick labels and pedigree to categorize practices, while outside the discipline, the public thinks that architects either "do residential" or "skyscrapers." The rich and complex interplay of space, aesthetics, customs, laws, economics, and politics is reduced to dumb labels of style and scale.

The pressure of having "a project", of self-defining a practice ahead of the work that it will do, is part of the problem. The manifestos of the 20th century cast a long shadow. Anxious to be part of the conversation, recently graduated architecture students and young practices scramble to find something to say, to define themselves, to prematurely brand themselves in order to differentiate themselves from the glut of architects graduating each year. This rush to brand legibility further stagnates the profession, unnecessarily typecasting and dumbing down the conversation. Tired tropes, expected ghosts, and recycled manifestos proliferate.

The best architecture emerges from fervent obsessions and passionate positions - by nature messy, plural, evolving, and incomplete. Forcing them into singular static position boxes and distilling universal truths is both reckless and limiting.

Heroic projects have played important roles in the history of architecture, disrupting modes of thought and galvanizing entire new movements. However, the singular, totalizing project no longer disrupts, but often simply gets lost in the crowd, just another loud cry amongst so many others. Even at its most sophisticated and thoughtful, the single project can have the unfortunate result of siloing the discipline, not into productively antagonistic camps, but rather into isolated cliques that rarely interact.

This is the shot across the bow against the project as such. Against the singular, universal, totalizing, and heroic project. This is a call for multiple projects, or more precisely, a call for an open project.

The complexity and pace of our increasingly unstable, mediated, and connected world demands a new architectural agility. Architects must adapt a schizophrenic mindset, passionately consumed by multiple

projects at once. Out of this multiplicity, a new open project emerges, in the parallax view between several heterogeneous projects. In the often delirious gap between the budgets, contexts, and politics of programs as diverse as a residential extension, a masterplan, an exhibition, and an art museum, architects can't possibly stretch a singular project to encompass them all. And the whiplash between sites and contexts is only growing as the role of the architect continues to expand - to curator, activist, entrepreneur, consultant, brand advisor, event coordinator, and even financial planner.

The open project is a kind of triangulation between a series of instincts, intuitions, and hunches. It is motivated by the local granularity of each single project; the particular concerns, questions, associations, agendas, and theses developed for each context. At our best we leave our preconceptions at the door, but bring all of our diverse and often irreconcilable obsessions with us.

* * * * *

The open project requires our ongoing participation in its making. It requires that we trust and nurture our instincts in the face of fashions and established schools of thought. It is highly motivated and carefully considered, but it is always multiple, almost, and just out of reach. It resides in the particulars of what lies in front of us, in our immediate local (a local that always points to and is complicit with the global). The open project is loose without being limp. It is contingent without being indeterminate. It is flexible, but not endlessly so. It is open without being ambiguous. It measures the world as it presents itself and allows life to unfold in all its complexities. The open project has many particular agendas, but no overarching schema. It recognizes that each project has different ingredients, so the final meal will always be different. The open project embraces the humanness of the architect, with her own subjectivities, opinions, fears, hopes, proclivities, and obsessions. It rejects the *a priori*.

The open project celebrates architects as collectors, as observers, as gatherers. It seeks out spatial logics that draw us in and keep us looking. It is both more of the same and something different. The open project is always relative and it doesn't always add up. The open project demands that each of us take a position, but only provisionally. The open project celebrates the unexpected discovery. The open project is playful. It is spatial, visual, aural, and physical. It is messy, subjective, opportunistic, flawed, open to interpretation, nuanced, and personal. The open project is unfinished.

The future cannot be attempted through universal, totalizing, or definitive agendas. It must be chipped away at one thoughtfully considered and unexpectedly designed project at a time. Progress will not come through revolution, but rather in the loosely networked advances of an entire generation of architects working their hardest to stay tuned into the latest conversations, flows, whispers, trends, loopholes, and opportunities. Only in this way will we find our way to something truly new. It is a thousand small experiments (not one single manifesto) that will cut against the current global malaise.

In short, architects need to loosen up, stop worrying so much about defining themselves, open their eyes, look around, ask questions, nurture their obsessions, and get to work. •

00 Gottfried Böhm, Neviges Pilgrimage Church, Germany, 1962. Photo: Xristina Argyros. Fractured and singular, futuristic and ancient, material and ephemeral—a paradoxical space that is intensely contingent and casually monumental—Böhm's church is a provocation (and diagram?) for our current social, political, cultural, and, by extension, architectural moment. We can't quite tell what it is, but we're hooked, and we need to look closer.

01 Daniel Gustav Cramer & Haris Epaminonda, *The Infinite Library, Book #24*, 2011.

02 Max Bill, *Variation 12*, 1938. Image Courtesy http://blog.andreasneophytou.com.

03 "Call to Action" is just what it says, a passionate plea for an architecture of activism. Seven years after the start of the most recent economic downturn, at a time when war, poverty, terrorism, and disease proliferate, as many of the worst problems we confront reach a breaking-point, architecture seems crippled by crisis fatigue, unmotivated and listless. The discipline has fallen victim to a scarcity of both resources and willpower. This has not always been the case. There have been historical periods when architects demonstrated social agency and conviction—see the early modernist's advocacy for social housing and new forms of urbanism, Buckminster Fuller's attempts to use design to solve the earth's energy and resource problems in the 40s and 50s, or the many radical practices in the 60s that strove to subvert systems of power, or some of the grassroots attempts to rethink collective forms of resistance in the 90s and early 00s. What initiatives can architects take to make architecture count today? How must architecture evolve in order to make a relevant contribution? We each must define our role in a new architecture of activism.

04 According to Bill Buford, writing in *Granta* 8 (summer 1983), "Dirty Realism is the fiction of a new generation of American authors. They write about the belly-side of contemporary life – a deserted husband, an unwed mother, a car thief, a pickpocket, a drug addict—but they write about it with a disturbing detachment, at times verging on comedy. Understated, ironic, sometimes savage, but insistently compassionate, these stories constitute a new voice in fiction." Fredric Jameson, in his published lecture, "The Constraints of Postmodernism," *The Seeds of Time* (New York: Columbia UP, 1996), re-appropriates the term "dirty realism" in order to describe one strand of postmodern architecture—namely the messy, program-driven, simultaneously universal and localized architecture of Rem Koolhaas and his OMA. Stan Allen has more recently used the term to describe the work of SANAA, and to draw parallels with the earlier projects of OMA, especially their shared concern for the "space of activity, the messy realm of movement and public interaction." (from "SANAA's Dirty Realism" in Florian Idenburg ed., *Learning from Japan: Single Story Urbanism* (Baden, Lars Müller, 2009). Finally (for now) a small offhanded thought from Jonathan Franzen's *The Corrections* brings the term full circle and back to the literary world. He writes that it's "Odd to glimpse infinity precisely in a finite curve, eternity precisely in the seasonal" (330). Savagely messy locales that point to the global, and insistently messy totalities that point to the local. To be continued …

05 Warlimpirrnga Tjapaltjarri, *Wilkinkarra (Lake Mackay)*, 2012. Image Courtesy Scott Livesey Galleries.

06 Roni Horn, *TOO V*, 2000. Image Courtesy Hauser & Wirth.

07 Gerhard Richter, *Stadtbild Madrid [Townscape Madrid]*, 1968. ©Gerhard Richter, 2013.

08 In 2007, the British artist Mike Nelson created an installation entitled "A Psychic Vacuum" which filled the abandoned Essex Street Market in New York City's Lower East Side with a tangled warren of rooms and corridors. Disoriented, the visitor emerged from the labyrinth into a large undistinguished room filled with sand. Slowly, and only after some concerted spatial arithmetic, it became clear that the spaces just inhabited were in fact buried beneath this pile of sand. Covered completely, the legibility of the spatial void hovered just beyond reach as one's mind struggled to reconstruct its recent spatial history. Stubbornly unstable in form, the void nonetheless remained conceptually vibrant in its overt obscurity—in the nagging presence of its absence.

09 John Stezaker, *Marriage (Film Portrait Collage) XXXI*, 2007. Image Courtesy Saatchi Gallery.

10 Plan of Hammam ar-Raddi, unknown source. See also entry #13, Insides with No Outsides.

11 NEIHEISER ARGYROS, Iconic Banal, 2008. Typical floor plan for a midtown high rise with iconic monumental void. Unrealized.

12 Scale relates, locates, sizes, and stabilizes. It offers a history and proposes a future. It authenticates. It confirms pedigree. It provides a common point of reference. It is the descriptive placard next to the work of art. It is useful, and it is complicating. It too often gets in the way.

13 Fredric Jameson, in his published lecture, "The

Constraints of Postmodernism," *The Seeds of Time* (New York: Columbia UP, 1996), to help describe one strand of postmodern architecture that he calls "dirty realism," (seen entry #04 above) references the "cyberpunk" aesthetic first described in Gibson's early novel *Neuromancer*, and visualized later in the movie *Bladerunner*, both distinctly dystopic visions of the future told from the vantage of the early 1980s. But he also identifies characteristics of these former futures—"interfusions of crowds of people among a high technological bazaar with its multitudinous nodal points"—in the globalized reality of the 1992 present of his lecture. Jameson calls this new present, this increasingly complex and abstract system of interrelations, the "unmappable system of late capitalism itself." For Jameson, the present has become one giant "inside with no outside", unable to be seen in its entirety and too unstable to support a distinguishable future. How do we conceptualize (and therefore render legible) this type of formless interiorized space? How do we comprehend the shape of a space with no exterior, an inside with no outside? The challenge is that there is no way to get any distance from these spaces, no exterior vantage from which to "take it all in."

14 Jean-Marc Bustamante, *Tableau*, from the series *Landschappen* 1978-1982. © Galerie Paul Andriesse, Amsterdam.

15 This is a manifesto for a new architectural agenda, one that reclaims a social and political agency for geometry. "Participatory Geometries" are spatial logics that draw us in and keep us looking, that transform passive gazes into active movements, and that demand that each of us take a position. "Participatory geometries" create architecture that supports multiple readings and interpretations, architecture that people will disagree about, architecture that engenders an engaged public.

16 Rosalind Krauss, in her article "Grids" from 1979, recognizes the grid as a persistent emblem for the modern in visual art and outlines both a centrifugal reading of the grid that compels acknowledgement of a world beyond the frame, and a centripetal reading that understands the grid as mapping the space inside the frame onto itself. Alan Colquhoun has argued that functionalism in the modern movement was not simply about utility, but rather the unification of the mechanical and the spiritual. Krauss locates the grid's power in its ability to suggest logic while simultaneously providing "a staircase to the Universal." It is precisely in this shared notion of an overtly cool functionalist logic subverted by, yet coexistent with, an undercurrent of irrational significance, which explains the happy marriage of the visual effects of the grid with the intentions of the modern movement.

17 Jean Prouvé, *Chaise Standard*, 1930.

18 The Monument on Flagler Memorial Island, an uninhabited artificial island in the city of Miami Beach in Biscayne Bay, Florida, United States. Courtesy of the Florida Photographic Collection, 1922.

19 NEIHEISER ARGYROS with Giancarlo Valle and Benjamin Critton, Streetfest Competition Entry #1, *City Within a City*, 2013.

20 Richard Long, *A Line and Tracks in Bolivia*, 1981. Participating in the shaping of a void.

21 The open project is a kind of triangulation between a series of instincts, intuitions, and hunches. It is motivated by the local granularity of each single project; the particular concerns, questions, associations, agendas, and theses developed for each context. The open project requires our ongoing participation in its making. It requires that we trust and nurture our instincts in the face of fashions and established schools of thought. It is highly motivated and carefully considered, but it is always multiple, almost, and just out of reach. Umberto Eco's, *The Open Work*, is an obvious reference here, a helpful point of departure.

22 *Another Pamphlet* is perversely anachronistic—it is printed on paper and distributed via, gasp, the post. Against the haze of digital distraction we crave an object to hold our attention—something to touch, to fold, to tuck in our back pocket, to discard.

23 Harold Bloom, *The Anxiety of Influence: A Theory of Poetry* (New York: Oxford University Press, 1997). On page 6 Bloom quotes Oscar Wilde, "Influence is simply transference of personality, a mode of giving away what is most precious to one's self, and its exercise produces a sense, and, it may be, a reality of loss. Every disciple takes away something from his master."

24 John Miller, *Social Portraits*, from the show "Counterpublics". © John Miller, Courtesy of Campoli Presti, London.

25 Georges Candilis, Alexis Josic & Shadrach Woods, Free University Building, Berlin, 1963.

26 Carlo Scarpa, Olivetti Showroom, Venice. Photo: Ryan Neiheiser.

27 Le Corbusier, Beistegui Apartment, Paris, 1929. Beautifully demonstrating the power of the frame, and the role architecture plays as an instrument for editing.

28. Minor revolutions occur all around us. Objects collide, translate, rearrange, emerge, subside, accumulate, associate, collapse, and decay. This world we inhabit—this city, this building, this stuff that surrounds us. This matter. This material. It acts, agitates, and networks, just like you and me.
29. Oswald Mathias Ungers, *The City in the City - Berlin: A Green Archipelago*, 1977. The image that launched a thousand ships . . . A galvanizing diagram for a tactical formalism, an empowering role for architecture in the making of the city.
30. Ernesto Lapadula, Giovanni Guerrini & Mario Romano, Palazzo della Civiltà Italiana, competition winning entry, Rome, 1938. Seamless juxtaposition of the modern cube and the classical arch. According to George P. Mass, there exists only one building in Rome that "rises above the level of uninspired neo-classicism . . . to place itself in the past, present, and future simultaneously." See George P. Mras, "Italian Fascist Architecture: Theory & Image," *Art Journal* 21. No. 1 (1961). See also entry #41 below, "the future as present."
31. "I am for an art that takes its form from the lines of life itself, that twists and extends and accumulates and spits and drips, and is heavy and coarse and blunt and sweet and stupid as life itself."
—Claes Oldenburg.
32. NEIHEISER ARGYROS, Data Center Spa Hybrid, 2012. While architectural forms repeat themselves throughout history, programmatic innovations can allow for new architectural typologies to emerge. The project rethinks the box-like, monolithic nature of data centers and proposes a thermal spa and tropical garden that capitalize on the wasted energy produced by the servers. In this case, the datacenter "box" is hollowed out as a public space, and a new hybrid infrastructural/architectural typology is imagined.
33. Bridget Riley, *Bagatelle 2*, 2015. © Bridget Rile. Image Courtesy Karsten Schubert Gallery. Also, see note #31 above, on "Participatory Geometries."
34. Le Corbusier, Carpenter Center for the Visual Arts, Massachusetts, 1963.
35. Vitruvius makes a distinction between symmetry—the proper internal arrangement of the parts of a work—and eurhythmy—the proper arrangement of objective proportions relative to a subjective observer. The ability of the observer to think and move introduces contingency into an otherwise stable condition.
36. Brice Marden, *The Attended*, 1996-9. © Brice Marden.
37. Yve-Alain Bois has traced the emergence and evolution of this radically new concept of space, one legible only to the moving spectator. In his article "A Picturesque Stroll Around Clara-Clara" of 1983, Bois identifies a strand of thought working against the classical notion of a unified, *a priori* sense of space and suggests in its place what he calls a modern picturesque space. He writes, "this space, from Rodin to Serra, is one of passage and displacement from the center, a space interrupted by the discontinuous time of involuntary memory, a slender space whose divergences it is up to the spectator to explore, while eventually connecting its threads for himself."
38. Moscow metro map. Drawing by Ryan Neiheiser. See entry #37 "Modern Picturesque", entry #15 "Participatory Geometries", entry #13 "Insides with no Outsides", and entry #10.
39. An acknowledgement that everything we do has been done before, that everything we make comes from somewhere, and yet it is still worth doing, still worth making. In a new context, with a new agenda, in a new time, each act, each gesture, can be liberated from its past, and can be revolutionary. See the artist Harris Epaminonda's take on history and influence . . . "I simply never keep a record of the sources I am using. It is a decision and a liberating moment of freeing the object from its past." The word "another" contains this paradox, of simultaneously being both "more of the same, and something different." *Another Pamphlet*, another practice, another office, another project . . .
40. NEIHEISER ARGYROS, *The Gallery House*, 2015. A split personality house for the passionate art collector. The house weaves together spaces of domestic everyday life with idealized spaces for viewing art. On one side of the central axis of the house are rooms specifically crafted for viewing a range of different types of art, with carefully controlled light and room proportions. On the other side of the axis are individually designed rooms for living. The house curates the experience of both, forcing the inhabitant to constantly move back and forth between art and life, between spaces of contemplation and spaces of interaction. Acting as a sort of "palette cleanser", the house refreshes, or resets the inhabitant's mode of thinking throughout the day. Importantly, both types of space are always visually present - the warm glow of the fireplace visible from within the gallery, and vice versa, the newly acquired sculpture visible while preparing drinks for guests.
41. William Gibson, science fiction

author and inventor of the term "cyberspace," identifies a recent collapse of the future into the present. However, not only is the future already here, but for Gibson there is no future distinguishable from the present. He writes, "Fully imagined cultural futures were the luxury of another day, one in which 'now' was of some greater duration. For us, things can change so abruptly, so violently, so profoundly, that futures like our grandparents' have insufficient 'now' to stand on. We have no future because our present is too volatile. The only possibility that remains is the management of risk. The spinning top of the scenarios of the present moment."—William Gibson, *Pattern Recognition* (New York: Berkeley, 2003), 57.

42 Screen capture from *L'Eclisse*, Michelangelo Antonioni, 1962.

43 Henri Cartier-Bresson, Madrid, Spain, 1933. © 2015 Henri Cartier-Bresson/Magnum Photos, courtesy Fondation Henri Cartier-Bresson, Paris.

44 In Sert, Leger, and Giedion's famous position paper, "Nine Points on Monumentality" and in Giedion's subsequent essay, "The Need for a New Monumentality," the argument is made for modern architecture's necessary role in reordering the social landscape through the design of legible civic centers, monumental ensembles, and public spectacles. Monumentality, according to Giedion, springs from the eternal and inevitable need to create shared symbols that embody the collective activity, organization, or ambition of a particular people and time. The discrepancy between the picturesque space of Giedion's civic plaza (public subject as awe-struck witness) and the "modern picturesque" (see endnote #37) space of Koolhaas' Very Big Library competition entry (public subject as beguiled participant) reveals important divergences in their respective understandings of the status of monumentality. The "Nine Points" document invokes a monumentality that is the symbolic expression of a single "collective force," of "the people," and of a necessarily unified "consciousness." This stability, cohesiveness, and completeness is echoed in Giedion's call for a monumental architecture marked by legibility and spectacle. Koolhaas' project on the other hand, with its multiple ambiguous void shapes floating hidden from view, suggests multiple, contingent forms of symbolic expression; a monumentality dependent on active interpretation and interrogation. The monumentality of the Very Big Library proposal is located not hovering in the silhouette of the city skyline, nor emerging from the center of a large open square. It won't comfortably be captured in a post-card snapshot or easily abstracted into a letterhead logo. It is a newer monumentality, a monumentality that resides in the lingering memory of collective inhabitation.

45 NEIHEISER ARGYROS, *Civic Frame*, 2015. "The city was first and foremost a void, a marketplace, an agora, and all its subsequent development has been just a means of fixing this void, of delimiting its outlines."—Jose Ortega y Gasset, *The Revolt of the Masses*. Civic Frame is a new form of urban infrastructure. It is sixty individual and identical units that can be combined in an infinite number of arrangements to strategically delineate—or frame—the city. Civic Frame invents a new urban typology—part public park bench and part wall—the two functions symbiotically support one another. Civic Frame provides a flexible and participatory tool for provisionally establishing limits, edges, boundaries, and frames; empowering the urban citizen to define their own space for discussion, debate, expression, and engagement.

46 Giuseppe Terragni, Casa del Fascio, Como, 1932 – 1936.

47 "It exists in the mind / Before it's represented on paper it exists in the mind / The point—it doesn't exist in the world / The classic is cool / a classical period / it is cool because it is impersonal / the detached and impersonal / If a person goes walking in the mountains that is not detached / and impersonal, he's just looking back / Being detached and impersonal is related to freedom / That's the answer for inspiration / The untroubled mind." Agnes Martin, "The Untroubled Mind", 1993.

48 Collective legibility is the ability for a public to read that something has form . . . that something stands in contrast to its background—a figure against a ground. Importantly "legibility" is made plural here, to distinguish this idea from its association with the "monumental" and "new monumental." Collective Legibilities allow for multiple simultaneous readings, encouraging multiple publics to stake ownership (even provisionally) in the spaces of the city. Chantal Mouffe's formulation of "agonism" and Yve-Alain Bois' formulation of the "modern picturesque" are relevant here.

49 Koji Tajima, *Pattern*, 2013.

50 "The task at hand is to identify the originality and potential of a hybrid aesthetic model in constant interchange, highlighting the technical and conceptual complexity which such a model implies. It is in this challenge, which perhaps a few years ago could not be dared to be identified, where we should learn to look and see the

sense and pleasure of things and processes in which we build; forgetting the singular tense of the words – essence, truth, form – in order to articulate a new 'plural language', 'mestizo', and 'foreign' to transcendence: this is the beauty which is to come, the beauty of the 21st century." *Beauty in the XXIst Century* studio brief, Princeton University, spring 2007. Inaki Abalos.

51 Screen capture from *8 1/2*, Federico Fellini. Image of the actor Marcello Mastroianni; confident, relaxed, the epitome of coolness.

52 Everything, always, with enthusiasm.

53 Channa Horwitz, *Circles*, 1988.

54 The practice of architecture is as much an act of editing as it is an act of creative production. Out of the hundreds of often competing forces—constraints, ambitions, opinions, expertise, histories, and passions—the most profound act of the architect is that of reduction, of seeing through the noise to isolate a few clear notes. But this is more than an act of passive removal; it is a profoundly active gesture that requires great confidence and always necessarily risks nothing less than complete failure.

55 This is a call for an Architecture Without Qualities. Or, more specifically, a call for an Architecture Without stable, singular, or *a priori* Qualities ("To be worthy of criticism, a building must possess qualities." Colin Rowe, *Oppositions*, 1976). This is an architecture that attempts to free architecture from itself; from its obligations to provide a memorable image, to champion a recognizable style, or to endlessly invent new forms. An Architecture Without Qualities is not a retreat to the ordinary, or a denial of design agency. Architecture must deftly champion a position that teeters precariously on the knife-edge between seemingly intractable contradictions – a background architecture that is lodged in the foreground of our memories, a neutral architecture that charges inhabitants with an insatiable desire to participate, a formless architecture that reveals an underlying geometric rigor, a quality architecture without specific qualities.

56 NEIHEISER ARGYROS, *Urban Village*, 2015. A proposal for a mixed use development near a transit hub in Graz, Austria.

57 Superstudio, Liebe Grüsse aus Graz von Superstudio— New Graz landscape. A postcard from 1969. © Skira, 2003.

58 Mies Van Der Rohe, Lake Shore Drive Apartments, 1949.

59 Greg White, Svalbard, 2010.

60 Nothing is created from scratch; everything we design emerges from overheard ideas, continued concepts, and our observations of the world around us. We collect quotations, tear them out of context, and (re)arrange them in a new form. Architecture is a process of collecting, classifying, and synthesizing our magnificent obsessions, and then skillfully re-deploying them, projecting them out into the world.

61 NEIHEISER ARGYROS, *For a Newer Monumentality: Reimagining Les Halles*, 2009.

62 Walter Benjamin wrote, "What is decisive in collecting is that the object is detached from all its original functions to enter into the closest conceivable relation with objects of the same kind."

63 NEIHEISER ARGYROS, *Bazaar Urbanism*, 2013. A city within a city.

64 Photo of Buckminster Fuller's Montreal Biosphere in flames, 1976.

65 The work of the painter Charline Von Heyl has been described as a "dark playground of aesthetic transgression." Playful, unruly, disturbing, and intensely focused. In an interview of Charline Von Heyl in Bomb Magazine (Fall 2010), Shirley Kaneda wrote, "Each [Von Heyl painting] is simultaneously form-driven and formless, leaving one with both a strong afterimage and a shifting after-impression. The result is a suite of works that is unfriendly to its beholder, provoking the impulse to look further while refusing to stay within the mind." This shifty-ness is what we associate with the "darkness" above . . . like playing on a playground at dusk, when forms vibrate into contingent greyness.

66 Sculpture, Langen Foundation, near Neuss, Germany. Photo: Xistina Argyros.

67 Mel Bochner, *Three, Four, Five*. 1973. Image Courtesy Mel Bochner.

68 NEIHEISER ARGYROS with Giancarlo Valle and Isaiah King, *The Informal Grid*, 2012. An ideas competition entry on the 200th anniversary of the Manhattan Grid. The grid of the 21st century introduces new logics into the system, questioning the boundary between built and natural, challenging the stability of established neighborhood identities, transforming the symbolic into the associative, and rendering the formal informal.

69 NEIHEISER ARGYROS with Giancarlo Valle and Isaiah King, *Little Monsters*, 2012. Twelve unique chairs commissioned by the Storefront for Art and Architecture in NYC.

70 "As opposed to the purely formal possibilities opened up to architecture by new digital modeling techniques of the 90s (blobs or iterative computational patterns), there might be a newer—more potent, and revolutionary— form of digital architecture that has less to do with digital

representation techniques than with a conflation of digital IT organizations with energy collection and distribution organization. If architecture becomes both energy collection and information content production infrastructure (solar panels and a pc), and urban planning takes on the role of organizing systems of energy and information exchange, there seems to be the potential for a radical new form of both architecture and urbanism." From *New Geographies 04: Scales of the Earth*, Ryan Neiheiser and Julien de Smedt.

71 Claude-Nicolas Ledoux, Projet de cimetière de la cité idéale de Chaux, published 1804.

72 Jensen Klint, Grundtvig's Church, Copenhagen, 1921. Photo: Xristina Argyros.

73 Wade Guyton, *Untitled*, 2010. Collection of the artist. Photograph by Lothar Schnepf.

74 Mark Lombardi, World Finance Corporation and Associates c. 1970-84, Miami-Ajman-Bogota-Caracas (7th version), 1999. Image Courtesy Pierogi Gallery.

75 O.M. Ungers, Neue Stadt, Cologne, 1961 – 64. Image Courtesy Socks-Studio.

76 NEIHEISER ARGYROS with Chris Parkinson, Urban Platform, 2012. An urban wall within the city that collects, condenses, and distributes.

77 Graham Harman, in *The Prince of Networks: Bruno Latour and Metaphysics* (Re:Press, 2009). "The world is a series of negotiations between a motley armada of objects, some growing stronger through increased associations, others becoming weaker and lonelier as they are cut off from others. No object is merely matter, rubble to be moved around by the mightier actors. Each object is granted the dignity to participate." .

78 Luis Barragán, Barragán House, Mexico City, 1948-48. © Barragán Foundation.

79 "Repetition and discontinuity, paradoxically, are the two hallmarks of contemporary Athens: at a large scale, the Athenian urbanisation is repetitive and homogeneous—it lacks hierarchy, public space and a clear anatomy—while on the other hand, if we look at the scale of architecture, every city block is built in a fragmented and chaotic way." Pier Vittorio Aureli, Maria S. Giudici, Platon Issaias, "From Dom-ino to Polykatoikia." *Domus* 962, (October, 2012). See also, Gilles Deleuze, *Difference and Repetition* (London: Continuum, 2001)

80 Rundetaarn, 17th century, Copenhagen. Photo: Xristina Argyros.

81 NEIHEISER ARGYROS, Wellness Center, 2015. Participatory geometries organize overlapping interior and exterior spaces.

82 Tacita Dean, *The Russian Ending*, 2001. Image Courtesy Niels Borch Jensen.

83 NEIHEISER ARGYROS mark, logo, signature, icon, trademark, gesture, whim, association, hunch.

84 Gottfried Böhm, Neviges Pilgrimage Church, Germany, 1962.

85 Hal Foster has written of Gerhard Richter's work that each new painting, or new series, "can appear somehow casual, almost interchangeable, even when they are highly wrought and quite individual," evoking the "condition of the blasé" ("Semblance According to Gerhard Richter", in *Gerhard Richter*, October Files, p. 119). For the author Georg Simmel, this blunted (blasé) sensibility meant a loss of ones capacity to value differences; a world of low contrast. But in Richter's work, Simmel's capitalist grey malaise is paradoxically harnessed as a productive aesthetic strategy. Without a context or narrative to provide scale, we must drift through the fog ourselves. When nothing in particular is worth getting excited about, everything acquires a slight glimmer.

86 Gabriel Orozco, *Asterisms*, 2012, Solomon R. Guggenheim Museum. The open, collected, provisional, evolving, and entirely subjective project.

87 NEIHEISER ARGYROS with Giancarlo Valle, Linda Farrow Eyewear pop up store, New York, 2012. A refined formlessness.

88 Alfred Hitchcock, *North by Northwest*, 1959. Still image from final scene, on top of the monument.

89 "Despite many funeral celebrations, the author has not so much died over the past 50 years as repeatedly come back to ever proliferating forms of anonymous life from bureaucracies and corporations to avatars, algorithms and hydrastars. Today, rather than subjects and objects, producers and consumers, authors and readers, we are surrounded by phenomena that alter the world through variable forms of anonymous exchange."— Sylvia Lavin's introduction to the "Anonymous" conference at the Princeton University School of Architecture; Saturday, November 9, 2013. Anonymity underlies the *Another Pamphlet* project as well. From the invitation to participate sent out to all contributors . . . "Above all it is a group effort. Distinct voices are provisionally brought together into a contingent collective. But while the contributors and the ideas they offer are vital, particular authorship is obscured. The authors are given credit for participating, but the ideas stand on their own. The collective dialogue is given primacy over the individual position."

90 Le Corbusier, rendering of Plan Obus for Algiers, 1933.

Body Politic

Bryony Robert

On October 2, 2015, forty young people from the South Side of Chicago picked up white plastic rifles and flags and performed fast-paced drill routines in Ludwig Mies van der Rohe's Federal Center. Moving in mass synchronization, this group of primarily African-American teenagers imitated, exaggerated and then transformed the lines of the Miesian space. Marching into the space in rows, precisely tossing and catching their rifles, they started to move with increasing energy and individuality, ultimately breaking into dynamic hip-hop choreography. Their movements throughout the performance were precise and self-possessed, creating a constantly moving field of gestures, spinning rifles, and twirling white fabric. Taking place in the heart of downtown during rush hour, the piece drew a large and varied crowd, ranging from office workers to tourists to architects. Some people started dancing along, some were crying, and many stayed to watch multiple

performances in a row. This performance, titled *We Know How To Order*, took place during the opening weekend of the Chicago Architecture Biennial, and was the result of a collaboration between myself and the South Shore Drill Team, a well-known performance group and youth organization from the South Side.

This project was an open-ended meditation on systems of ordering bodies in contemporary Chicago. In bringing together a space of federal authority designed by Mies van der Rohe and the South Shore Drill Team, the project points to a number of charged political themes – the role of architecture in structuring public space, the treatment of black bodies by government authorities, and the prevalence of gun violence in Chicago. But the piece is not simply a critique of architecture or federal authority since it also reveals surprising similarities between the militaristic defense of government space and the discipline of the Drill Team. Instead of proposing one critique or one answer, the project simply places two Chicago institutions next to each other – the Federal Center and the South Shore Drill Team – to show the resonances and differences in ways of ordering the body and controlling the unknown.

The title for *We Know How To Order* comes from a poem by Gwendolyn Brooks, a poet from the South Side of Chicago. Writing in 1944, she describes the inner conflicts of African-American soldiers fighting in World War II. Shaped by military training and etiquette, they gain an armour of confidence in conversing with white soldiers and in seducing women. "We knew how to order," they state proudly, but on the battlefield, the fragility of the order reveals itself. There, "*No stout / Lesson showed us how to chat with death. We brought / No brass fortissimo, among our talents, / To holler down the lions in the air.*"¹

1 Gwendolyn Brooks, "Gay Chaps at the Bar," *Poetry Magazine* (November 1944), 76.

Both the Federal Center and the South Shore Drill Team produce systems of order to protect against the unknown, to keep out their own "lions in the air."

In the case of the Federal Center, the grid system underlying the architecture produces a highly unified and contained space, which has been enhanced by security measures since September 11. Designed by Mies van der Rohe, the Federal Center is an impressive complex of three buildings of Federal govenment offices, all unified by a grid of 4'-8". The complex was built between 1959 and 1974 at a time when mayor Richard J. Daley promoted modern architecture within the Loop as a bolstering of civic identity. Mies van der Rohe, then the director of the Department of Architecture at IIT in Chicago, was leaving his mark on the city with a series of tower complexes, each recognizable with their exposed steel structural frames and open ground floors. As an alignment of political interest, architectural ambition, and Federal authority, the Federal Center is a forceful urban project. The consistency of the Miesian grid creates a unity across three separate buildings of different sizes and the open plaza between them. The tight architectural alignment produces a sense of boundary and enclosure, despite the traffic of South Dearborn Street, which moves directly through the site. Although the glass-enclosed ground floors create visual transparency, the complex nonetheless maintains a sense of enclosure and separation from the surrounding city with its consistent black facades and inward focus. As a result, the public plaza in the center, ostensibly open to anyone, is usually deserted. After September 11, 2001, concrete bollards were added around the perimeters of all of the buildings following the lines of the existing grid. There are multiple layers, then, of architectural ordering systems, contemporary security boundaries and surveillance, and experiential conditions of openness and transparency.

In contrast, the South Shore Drill Team operates on the South Side of town, an area shaped by very different urban planning ambitions. While Mayor Daley was encouraging development in the Loop, he was also driving slum clearance efforts on the South Side and promoting the construction of large public housing towers. Much has been written about the politics of public housing in Chicago in the 1950s and 60s and its consequences for the black community. But some significant facts include that Daley drove out the advocates for integrating public housing into existing neighborhoods, and instead instigated the isolation

of housing projects, especially from white communities.[2] Chicago is now one of the most segregated cities in America, with staggering figures for gun violence and youth mortality among the South Side in particular.

In this context, the South Shore Drill Team produces systems of order to protect young people against the violence around them. The Drill Team is an unusual combination of a performance group and a social institution. Although drill teams are common in U.S. high schools, the South Shore Drill Team is unique for both its integration of hip-hop choreography and its existence as a non-profit community organization. Founded in 1980 by Arthur Robertson, a public school teacher, the South Shore Drill Team structures a complete lifestyle for its participants, occupying them after school with tutoring, job training, counseling and long practices for performances. The Drill Team produces a system of order and maintenance for its participants' bodies—during the rigorous rehearsals, it coaches train precision and discipline through endless repetition, and the organization often provides meals for the participants during rehearsals or after performances. The lineup of 85 performances

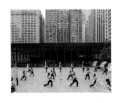

every year is designed not only to promote the team, but also simply to keep kids out of the neighborhood, especially on weekends such as the 4th of July when gun violence is most prevalant. Its impact on young people is enormous—both by physically keeping kids away from violence and by psychologically imbuing a sense of confidence, importance, and ability in young people who are often treated as dangerous and unworthy. Their efforts to train discipline and self-control—from the rigor of drill routines to the politeness of greeting strangers—resonate with the lines from Gwendolyn Brooks' poem. Here again, the rigor of military-inspired discipline aims, with varying success, to keep danger at bay.

My role in this project was to bring together these two major Chicago institutions – the Federal Center and the South Shore Drill Team. As an architect and artist, I was invited to participate in the Chicago Architecture Biennial in which I proposed a mass movement performance at the Federal Center. Originally, the project was an abstract meditation on visual systems of order, involving dancers who would create a moving drawing through their movements and the use of simple white rods. But after searching for a performance group, I found

2 Roger Biles, "Race and Housing in Chicago," *Journal of the Illinois State Historical Society* (1998-), Vol. 94, No.1 (Spring, 2001), 36.

the South Shore Drill Team and saw immediately that their history and their use of rifles and flags would be a more powerful response to a Federal government space. This project took shape in the spring of 2015 as the Black Lives Matter movement was gaining momentum and protests were spreading after the release of officers involved in the deaths of Michael Brown and Eric Garner. In Chicago in particular, a staggering number of young people were shot in 2015, including some of the members of the South Shore Drill Team. These events made it painfully clear how far our country is from overcoming institutionalized racism and inequality. Since the architecture field rarely engages racism and inequality directly, it seemed to be an important moment to raise these issues in the public forum of the Biennial.

The combination of the Federal Center and the South Shore Drill Team calls attention to the resonances and frictions between them. Architecturally, the Federal Center is rooted in the logic of the grid, as both a unifying and ordering device. Similarly, the Drill Team relies heavily on grids to give visual order and coherence to their routines. But beyond these formal similarities, there is a complex resonance around militaristic discipline. The Federal Center, a manifestation of government authority, is patrolled by policemen and officers from Homeland Security. Some of the guards themselves are familiar with drill routines from their time in the army, and some of them have performed themselves, as I learned from conversations with them. On the flip side, the Drill Team, which hails from a community with a complicated relationship to the police, has appropriated militaristic drills for its own particular form of discipline, which protects young people from the dangers of the neighborhood. Both employ militaristic discipline but approach it from opposite sides. For the Federal Center, to protect from dangerous individuals – a blanket category which, due to racial profiling, could be imposed onto young people from the South Side. For the Drill Team, to protect young people from violence, be it from civilians or the police. The images of authority, and even of violence itself—uniforms, rifles, flags—become symbolic deterrents against future violence. What is so powerful about the Drill Team is how they splice rifle drills with street choreography to create fast-paced oscillations between gestures of authority and expression, cycling through systems of disciplining, ordering, and empowering their own bodies.

✳ ✳ ✳ ✳ ✳ ✳
 ✳ ✳ ✳ ✳ ✳
 ✳ ✳ ✳ ✳

The process of designing and producing the project was itself charged with political dimensions. Both the conventions of architectural authorship and of the Drill Team's client relationships produced challenging power relations. The Chicago Architecture Biennial invited me to participate as an architect, and many of the participants in the event functioned as individual designers producing objects or installations. The emphasis, in terms of promotion and mediation, was on individual authorship. For this collaboration, I conceived of and conceptualized the project, but it was choreographed and produced by the South Shore Drill Team. Media tended to emphasize my authorship, and there was a great risk of this seeming to be another case of white 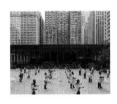 exploitation of black talent, given my position as a Causasian woman working with a primarily African-American organization. Among their 85 performances a year, the South Shore Drill Team does many performances for hire and is used to a conventional client relationship in such cases. With so many performances on their schedule, it is also difficult to make time for an open-ended collaborative process. The easy default would have been for me to make all of the decisions and for them simply to execute them—to fall into the very trap that we had all wanted to avoid. But it was important to everyone involved in the project—myself, the choreographer Asher Waldron, and the Biennial team included—that this be an exchange of ideas and a moment for the Drill Team to make their own interpretation of the Federal Center. Therefore, a large part of the work of this project went into communication—both my communication with the choreographer Asher Waldron to make sure this was an equal exchange of ideas, and communication with the Biennial and press to clarify the collaborative authorship. Every statement about this project was rewritten dozens of times in response to conversations, both to refine the language about race and to refine the credit and authorship of the project.

The project also put into play a distribution of resources outside of the architectural circuit. The bulk of the budget for the project went to the South Shore Drill Team as their fee. The money they receive for

performances then goes into the tutoring, rehearsal, and meal programs at their community center. The advantage of an ephemeral project is that the bulk of the funding can go towards labor rather than construction or material costs. Performance art can become a funnel of resources—in this case from the corporate sponsorship of BP to a community on the South Side of Chicago. This, of course, only makes a small dent in the operating budget of the Drill Team and in the wealth of BP, but nonetheless offers one way of how design can channel resources.

* * * * *
* * * * * *
* * * * *

We Know How To Order raises questions about how architecture organizes bodies in space, but also how bodies can remake architecture. It is perhaps too obvious to see Mies' architecture as a relentless system of grids that structure human movement. Less obvious is the potential for contemporary users to remake Mies' architecture, or any architecture, with the medium of their own bodies. Landmark buildings, especially those by legendary architects such as Mies van der Rohe, are valued and described only in terms of their original authorship. But subsequent users can radically transform these spaces through their patterns of use, spatial alterations, and differing cultural perspectives on its architectural history. It is crucial to begin acknowledging the importance of these subsequent authors, and to complicate the expectations for only singular, original authorship within architecture. In particular, it is important to make space for other authors often excluded from conversations about architectural landmarks and their influence on the city. Part of the ambition of this project was to invite young people from the South Side, who are not normally made to feel comfortable in such spaces, to remake Mies' architecture on their own terms.

Finally, the prospect of bodies remaking architecture offers an alternative to architecture ordering bodies. Writing about gender, race, and architecture typically focuses on the agency of architecture in shaping the movement of bodies and social relations. Critical discourse often points to white male architects as agents who shape spatial types to configure the publicity and privacy of different groups. But what if we think about bodies remaking architecture? Certainly there is a long

FROM

lineage of guerrilla appropriations and occupations of existing spaces, from squatters and Happenings to the Occupy movement. Often such practices emphasize just the physical occupation of the space, the transgression of its expectations, as the end goal. What if we think more expansively about how bodies can redraw and reconstruct architecture? How bodies can construct other structures of enclosure, movement, and interaction. In *We Know How To Order*, the performers produce physical drawings based on the Miesian grids, but they also multiply and transform those grids beyond all recognition with their individual, expressive movements. The architectural references are there, but they are also lost in the tangible, living energy of the performers. When Mies becomes a moving field of empowered young black people, is it still Mies? •

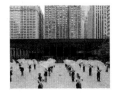

* * * * * *
* * * * * *
* * * * * *

We Know How To Order
Bryony Roberts + South Shore Drill Team
Chicago Architecture Biennial, October, 2015
Federal Center, Chicago
Photographs by Andrew Bruah

10 Steps for Making Architecture from Architecture

Andrew Kovacs

MAKING ARCHITECTURE FROM ARCHITECTURE

Making Architecture from Architecture is a pursuit with the aim of grasping the width and depth of architecture. If architecture is a way that we organize the world around us, then *Making Architecture from Architecture* is about evaluating what exists and rearranging that material towards architectural purposes. This is a pursuit that tracks the qualities and traits of architecture.

2

DEFINITION

Making Architecture from Architecture requires that architecture first must be defined and identified. Not everything and anything can be architecture, but what *is* architecture may at first be unexpected. *Making Architecture from Architecture* is sympathetic in outlook so it can discover what architecture is. *Making Architecture from Architecture* is relentlessly unbiased, inclusive and opportunistic: no architecture is greater, or less than any other architecture. All architecture is equal.

THE SEARCH

The material to *Make Architecture from Architecture* makes itself apparent during the search. This search is a state of controlled randomness. The search is not specific. While there is a selection criteria for this material, it is not based on individuals, theories, or movements. The material to *Make Architecture from Architecture* is the result of a incremental process of drifting and browsing. The search is painstaking and requires an investment in time. Often the search yields no apparent results.

4

THE SELECTION

During the search, architectural images and objects are selected based on their qualities. The qualities range from size, form, shape, mass, proportion, character, posture, figure, organization, distribution, color, recognizability, and so on. Selection is about making choices. The materials selected may appear to be wholes but are to be understood as fragments. Fragments that are extradited from the baggage of their original context, and placed into a reserve where they wait to be redeployed in a new context.

THE SCANNER

Once images and objects are selected they are scanned. The scanner is a leveling device for all gathered images and objects. The material that has been tracked and hunted is equalized first by scanning and then by archiving. The original context is erased. This record of scanned and archived images and objects is not an end itself, it is material waiting to be mobilized.

ARCHIVE OF AFFINITIES

Archive of Affinities is the complete up to date digital record of the search, the selection and the scanner. It follows a logic of producing affinities. As a continuously growing whole, *Archive of Affinities* reflects personal predilections, tastes, and interests. *Archive of Affinities* also creates relationships between digitally recorded images and objects. In the process of its generation *Archive of Affinities* is a barometer, measuring both individual and collective sensibilities.

Archive of Affinities, 25 Square Plans

From Left to Right:

Bertram G. Goohue, Nebraska State Capital, Plan, Lincoln, Nebraska / Julian Elliott, Plan of the Pilcher House, Zambia / Typical Plan of Ancient Moorish Dwelling, Prepared by C. Uhde / Emilio Ambasz, Houston Plaza Center, Plan, Houston, Texas, 1982 / Linlithgow Palace, Plan, Linlithgow, West Lothian, Scotland, 15th–17th Centuries

Oscar Niemeyer, Maison de la Culture, Plan, Le Havre, France, 1972–1982 / Qasr Kharana, Plan / Frank Furness and George Hewitt, Jefferson Medical College Hospital, First Floor Plan, Philadelphia, Pennsylvania / Hans Hollein, Rauchstrasse, House 8, Plan, IBA Apartment Building, Berlin Germany, 1983 / E. Matveeva, E. Perel'man and L. Dunkin, Design for a Sports Complex with Swimming Pool, Plan 1983

Plan for the Margravate of Azilia, Georgia, 1717 / Edward Durell Stone, North Carolina State Legislative Building, Plan, Raleigh, North Carolina, 1960 / Anthony Ernest Pratt, Cluedo Board Game Patent, Plan, 1947 / Philip Johnson and John Burgee, General American Life Insurance Company, Plan, St. Louis, Missouri, 1977 / J.N.L. Durand and J.-TH. Thibault, Plan of Temple Decadaire

Le Corbusier, Early Plan for the Governor's House, Chandigarh, India, 1952 / Skidmore, Owings & Merrill, Boise Cascade Home Office, Floor Plan, Boise, Idaho / Loro Jongrang Prambanan, Plan / James Stirling, Low Cost Housing, Floor Plan, Basic Four House Clusters, Lima, Peru, 1969 / Mies van der Rohe, Sketch for a Concert Hall, Project, 1942

Sebastiano Serlio, Château d'Ancy-le-Franc, Plan, France, 1544–1550 / Egyptian Labyrinth, Plan / Pyramid of the Niches, Plan, El Tajin / Johannes Duiker, Open Air School, Plan, Amsterdam, The Netherlands, 1930–1932 / Harry Weese, Village Hall, Floor Plan, Oak Park, Illinois, 1971–1974

THE IMAGE BANK

Archive of Affinities is similar to, but different than, an image bank. An architect's image bank is a way to gather inspiration and measure their output with that of the past. At a certain volume of images, the image bank inevitably begins to chart lineages between architects and architecture. The image bank conforms to traditional hierarchical structures of time, movements, and individuals. Through comparison, the image bank becomes a tool of reference and precedent – one of the ways architects have previously attempted to make architecture from architecture. The architect's image bank has an importance in this regard, but it is limited in that it has a static existence. The image bank is trapped by its organization and file structure. And more often then not this results in a convention of disorganization initiated by file mismanagement, real time updates, and miscellaneous categorization. However this convention of disorganization when pushed to an extreme becomes important in the endeavor of *Making Architecture from Architecture*.

8

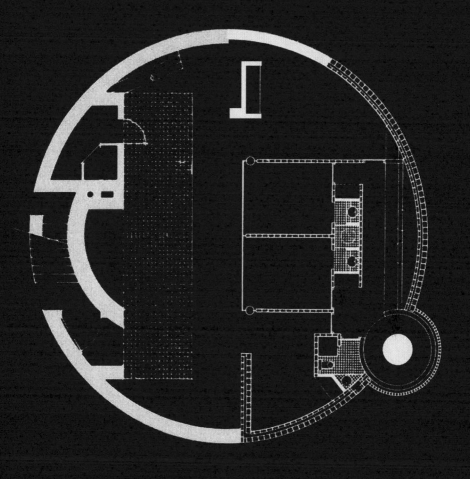

NO FILE (MIS)MANAGEMENT

An extreme lack of file management is different from file mismanagement. The most extreme lack of file management in the image bank places all images in a single folder and thus on an equal playing field. The openness of a single folder allows for serendipity. Lack of apparent organization compares and juxtaposes work that may have never had such an opportunity. Mess is more. The typical organization of the image bank forces material to remain separated and stationary, *Making Architecture from Architecture* views the material to be equal, transitory and awaiting assemblage. Once and image or object is recorded it becomes material that is available for the mobilization and production of new architectural images and objects. In the process of *Making Architecture from Architecture*, reference is exploited without reverence and precedent is employed perversely.

COMPARISON, CONTIGUITY & COMPOSITION

Making Architecture from Architecture is the production of the new from the existing. Comparison places all recorded affinities on equal footing and allows for the manipulation and alteration of the qualities or affinities such as scale, form, organization, and context. Contiguity is comparison pushed to its extreme. It occurs when the distance required to compare is collapsed and reduced to zero. In doing so, the composition of these altered elements is integral. *Making Architecture from Architecture* aims to produce new and radically contiguous compositions of the existing.

PRODUCTION THROUGH ADDITION

The undertaking of *Making Architecture from Architecture* operates on two levels. The first level employs procedures of browsing, searching, tracking, gathering, grouping, organizing, comparing, collecting, and selecting. The second aspect of making architecture from architecture is the constant production of new images and objects through procedures of flattening, copying, scaling, assembling, combining, compacting, mixing, reorganizing, altering, recasting, and proposing. The new productions might simply be architectural thought experiments, playful provocations, or speculative proposals. This process takes the material that was tracked and hunted and assembles it. This is ultimately a process of addition. Production is dependent on existing architectural images and objects that have been scanned and recorded in *Archive of Affinities*. The more that is gathered, the more can be produced. The material that is recorded may exist as a collection, but it does not remain as a collection. A collection is a terminus. In a collection once an image or object is acquired it has reached its end. *Making Architecture from Architecture* employs the logic of a collection, but it ultimately pushes that logic to a breaking point.

Biographies

ALESSANDRO TOTI

is an architect, educator and critic. Having studied architecture at HCU Hamburg, PUC Santiago de Chile and Roma Tre University, he has since taught architecture at the Roma Tre, Camerino and Cornell University. He has recently completed his MA in the Architectural History Programme at The Bartlett, and has published widely including numerous essays in magazines such as *Gizmo*, *Flaneur* and *SAJ*. And has recently collaborated with Gabriele Mastrigli on a book and exhibition on the work of the radical avant-garde group Superstudio.

JAFFER KOLB

is a New York-based designer and lecturer at Princeton University's School of Architecture. His work is dedicated to finding new sites for architecture in political and material economies through experiments in preservation and form. He was the 2015 Muschenheim Fellow at the University of Michigan, and before that worked as a designer in New York, Chicago, and Los Angeles. He worked on the 13th Venice Architecture Biennial under David Chipperfield, and before that served as the US Editor of the *Architectural Review*. His work has appeared in exhibitions internationally, and published in *Wired*, *Blueprint*, and *Abitare*, among others.

CRISTOBAL AMUNATEGUI

Amunátegui's work in architectural history focuses on the eighteenth- and nineteenth-century architecture of entertainment in France. In his research he pays special attention to the overlapping of aesthetics, technology and architecture in the modalities of commercialized entertainment deployed in the second half of the nineteenth century, inscribing these buildings and practices in the wider modern effort to produce 'absolute' accounts of the world. He has taught in various American and Chilean institutions, and articles about his research as well as on contemporary architectural culture have appeared in journals and essay collections in Chile, the US and Europe. In 2011 Amunátegui co-founded the office *Amunátegui Valdés*, which comprises the architectural work he and Alejandro Valdés have developed since 2000. The first monograph of their work will appear in December 2016. Currently he is a doctoral candidate in Architectural History and Theory at Princeton University, and a lecturer at UCLA.

JOSEPH BEDFORD

is an assistant professor of history and theory at Virginia Tech. He received his BA in architecture from Cambridge University; his B.Arch from The Cooper Union; is the holder of the 2008 – 2009 Rome Prize at the British School in Rome; and received his Masters in History, Theory and Criticism at Princeton University, where he is completing his doctorate. He is the founding editor of *Attention: The Audio Journal for Architecture,* and *The Architecture Exchange,* a platform for theoretical exchange between architecture and other fields. He has worked in practice with offices such as Michael Hopkins Architects in London and Architectural Research Office in New York and has taught architecture at schools such as Princeton University, Pratt Institute, and Columbia University. He is the author of numerous articles in journals such as *Architecture Research Quarterly, Log* and *AA Files.*

RYAN NEIHEISER

is an architect, urban designer, engineer, teacher, artist, writer, and editor. He is the co-founding partner of NEIHEISER ARGYROS with projects in the United Kingdom, the United States of America, and Greece. Prior to this, he worked at a number of firms in Europe and the United States, including Diller Scofidio + Renfro in New York, Julien de Smedt (JDS) Architects in Brussels and Copenhagen, the Office for Metropolitan Architecture (OMA) in Rotterdam, and KieranTimberlake in Philadelphia. Ryan has taught master's level thesis at Princeton University and is currently a studio Master Tutor at the Architectural Association in London. He is a co-founder of the architecture publication, *Another Pamphlet,* was a co-editor of the book, *Agenda: Can We Sustain Our Ability to Crisis?* (Actar, 2010), and has published articles in *New Geographies, Bidoun,* and *Pidgin.*

XRISTINA ARGYROS

is an architect and urban designer. Argyros is the co-founding partner of NEIHEISER ARGYROS with projects in the United Kingdom, the United States of America, and Greece. Prior to this, Argyros worked at a number of award winning firms in Europe and the United States, including WORKac in New York City, the Office for Metropolitan Architecture (OMA) in New York City, and Ateliers Jean Nouvel in Paris. She has previously taught at Cardiff University and is currently teaching a design studio at the Architectural Association in London. She is originally from Athens, Greece and has lived in Athens, Paris, and New York prior to moving to London in 2014. She is a licensed architect in Greece.

BRYONY ROBERTS

is an architectural designer and scholar. After working in the offices of WORKac in New York and Mansilla + Tunon in Madrid, she started her own practice in 2011. Her practice combines strategies from architecture, visual art, and cultural theory to transform existing architecture. Her work has received a Graham Foundation Grant and was featured in the Chicago Architecture Biennial of 2015, as well as in group and solo exhibitions in Rome, Berlin, Los Angeles, and New York. In addition to design projects, Roberts has published essays on architecture in *Log, Future Anterior, Architectural Record,* and *The Avery Review,* and recently guest-edited the architectural journal *Log* on the topic "New Ancients." She taught architecture at the Rice School of Architecture, at SCI-Arc, and the Oslo School of Architecture in Norway. She is currently the Booth Family Rome Prize to develop her work at the American Academy in Rome in 2015 – 2016.

ANDREW KOVACS

is a Visiting Assistant Professor at UCLA Architecture & Urban Design. He is the creator and curator of Archive of Affinities, a website devoted to the collection and display of architectural b-sides. Hi exhibitions have included GOODS USED: AN ARCHITECTURAL YARD SALE at Jai and Jai Gallery in Los Angeles and, in collaboration with Laurel Broughton, Gallery Attachment/As Builts sponsored by the LA Forum's John Chase Memorial fund and Storefront for Art and Architecture's World Wide Storefront program. Kovacs' work on architecture and urbanism has been published widely including *Pidgin, Project, Perspecta, Manifest, Metropolis, Clog, Domus,* and *Fulcrum.*

Utopia, Thomas More, 1518

'For more than three centuries printers of books appended at the foot of every page the first word or syllable of the next page. This catchword was supposed to be needed by the reader to make clear the connection between the two pages; but the catchword is now out of use, and it is not missed.'

De Vinne, Theodore Low (1901). *The Practice of Typography* (2nd ed.). New York: The Century Co. pp. 142 – 143.

To stay up to date with The Architecture Exchange, including updates on workshops, discussions and events, please visit:
www.thearchitectureexchange.com

Alternatively, The Architecture Exchange may be contacted by writing to:
info@thearchitectureexchange.com

Published by Architecture Exchange Press
Design: Twelve (www.twelve.la)
Typeset in *MF Bespoke* by metaflop
ISBN: 978-0-9983750-1-4

Copyright © The Architecture Exchange, 2016

Made in the USA
Middletown, DE
24 November 2017